you are formally invited to

.....................................................................................

in celebration of

.....................................................................................

because

.....................................................................................

let's get this party started.

kate spade

NEW YORK

# *celebrate that!*
# occasions

abrams, new york

kate spade
NEW YORK

it's no secret: we love celebrating occasions.

we love that occasions come in all sizes, from extra small
to extra large. the monumental ones, like a friend's first baby,
don't happen often in life, which makes them extra sparkly;
meanwhile all kinds of little ones in between the milestones
do. (we're looking at you, good parking spots, fridays, a new
skill . . .). your small wins have the collective power to shape
your everyday.

speaking of you, we also love that everyone has occasions to
celebrate. in between prepping your sister's birthday and
toasting your friend's promotion, make time to celebrate the
things that go right in your life and make you proud to be
you. every so often, invite your sister and your friend to
raise a glass to you, too.

just as there are all kinds of occasions, there are so many
ways to celebrate them. it is rare that they are huge parties,
but they are always moments of joy. on occasion, they're a
bit of joyous defiance in a hard world.

in this book, you'll discover lots of parties as well as lots
of not-a-parties, and our unique ideas, tips, tricks, and hacks
for doing it all in style.

in addition to dressing up and going out and feeling good,
what we love most about celebrations is that they have the power
to create and strengthen relationships, including the one you
have with yourself. they mark moments in time, both endings and
beginnings. they can give you strength to get through the day.
they can also help drive you forward. it's why we think the best
time to celebrate is whenever you can.

we've all got extra-small things and extra-large things to
celebrate and they all deserve the love. whatever gives you
(or them) that champagne-fizzy, flutter-in-the-tummy feeling,
we're all in. let's celebrate that.

XO,
all of us at
kate spade new york

celebrations are . . .

but first, a question.

# what's your *celebration* language

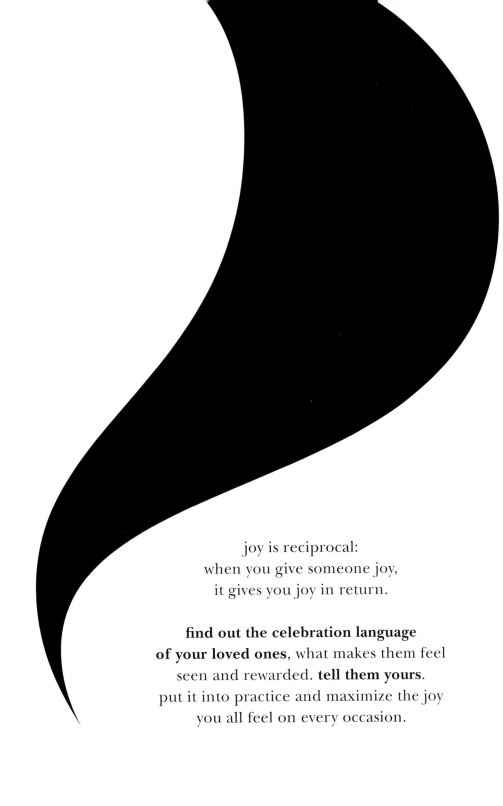

joy is reciprocal:
when you give someone joy,
it gives you joy in return.

**find out the celebration language
of your loved ones**, what makes them feel
seen and rewarded. **tell them yours**.
put it into practice and maximize the joy
you all feel on every occasion.

# choose one answer for each question.

note which letter(s) you got most. then read more about your type. you might be a mix of two.

**your favorite coworker just got promoted. you immediately give them:**

details on where you'll all be drinking champagne at 6 p.m. ......... b
feelings.................................................................................. a
ideas on how to decorate their new desk....................................... d
a bouquet of flowers................................................................ c
hugs. physical hugs. digital hugs. you're a hugger........................... e

**a moment of comfort:**

the banquette seat.................................................................. a
making a reservation................................................................ d
reading in the bathtub when the party starts in 10 minutes............... c
a hand on your shoulder as you blow out your candles.................... e
a fancy dress......................................................................... b

**you make a great impression:**

arriving................................................................................. c
entertaining........................................................................... b
setting the scene.................................................................... d
telling tales........................................................................... a
leaving.................................................................................. e

**a magical moment:**

eye contact............................................................................ e
a paper invitation.................................................................... c
first times.............................................................................. b
whistling................................................................................ a
clarity.................................................................................... d

**it matters:**

who you're with...................................................................... a
just being there...................................................................... b
if it comes in handy................................................................ d
a strong shoulder.................................................................... e
what's in the box, not the size of the box.................................... c

# *don't skip ahead, take the quiz*

### a. WORDS

a chorus of congrats is your thing both literally and figuratively, and behind every major win is a group text that's been hyping you up for it. you understand the power of quick-fire "good luck today!" texts, instagram stories shout-outs, sincere apologies, and random compliments, because your heart does a little "!" every time someone does one of those for you.

### b. PLACES

a natural partygoer and thrower, gatherings big and small—hosting them, orchestrating them, going to them—make you happiest. whether enjoying a drink with your closest friend or going to a bar-packed birthday bash, you celebrate everything surrounded by others. you know how to create a fun, warm, welcoming party, and you appreciate when someone goes all out for you, even on a night in.

### c. GIFTS

you love the entire process of planning, finding, making, baking, or arranging the perfect present, and seeing your lucky recipient's face light up when they get it. in return, finding even a bouquet of bodega flowers on your desk from your coworker for a job well done makes you smile, because you know they went out of their way to go get it.

### d. ACTIONS

you see gestures of all kinds as grand ones. at your best friend's wedding, you're the impresario in the room, running around, filling glasses, starting conversations, making sure all the guests are having a good time. and when you throw a party, you fondly remember the guest who was kind enough to show up with extra ice at your door. just in case you needed it.

### e. PEOPLE

you're a "pinch me is this real"–type person, except swap out the word "pinch" for any of the following: hand squeezes, slow dances, a pat on the back. then again, let's be real. if congratulations were snowflakes, you'd send that person a blizzard and then be the human blanket that keeps them warm. make no mistake: you love a hug.

occasions are all around.

extra small

# *morning to night*
# a day is a series of mini wins

THESE ARE THINGS THAT SET OFF sparks in your mind. acknowledge them, and if you're really lucky and mercury is not in retrograde, you might just get a whole day of little fireworks.

• *made the bed!* • getting the kids out the door on time • not spilling coffee on your coat • a really good deal • the text gets delivered right as your phone dies • *phew, i didn't step in that* • a fun first date • your day is running right on schedule • the thing you wanted went on sale. you got it • finishing that book on your nightstand • a good parking spot • a free upgrade • the perennials you planted last year are blooming again • an empty dryer • making every green light when you're running late • learned to do that thing • finding money in your pocket • walking onto the subway platform as the train arrives • acing that hard conversation • crossing everything off a to-do list • extra 15 minutes in the morning • a dress and bare legs day in early spring • getting the very last one (croissant, ticket, seat, thing in your size…) • making it to the dry cleaner to pick up your dress right before it closes • resolving that weird thing at home • taking off all of your eye makeup after a big celebration • *there's dessert and champagne in the fridge*

a fancy coffee.

a new something for your collection.

bodega flowers.

wear something you love.

leave work early.

bike or walk somewhere you've never been.

sneak out for lunch.

a glass of champagne in the bathtub.

draw, color, paint.

say "yeah!"

go sit in the garden.

# *remember to*
# self-reward the little things

go get some fresh air.

pick up a book and read it.

mint chip ice cream.

take the scenic route home.

disco nap.

your favorite takeout, delivered.

binge-watch a show.

slide that chore to tomorrow's to-do list.

have an early night.

buy that thing you just added to your wishlist.

do nothing. it's really something.

you know what makes
me happy?
unexpected phone calls in
the middle of the day.
remembering what i liked at that
one restaurant we went to
that one time.
half-dead grocery store flowers
just because
they were on sale.

—SAMANTHA IRBY,
*meaty*

forget the rules.

small

# it's your *half* birthday

WHEN IT COMES TO MARKING THE PASSAGE OF TIME, birthdays tend to hog the spotlight, and for good reason. what better day than the one when you arrived on this planet to reflect on where you're going and where you've been, and have a slice of cake or two? even so, life is what happens in the 364 days between birthdays.

enter *the half-birthday.*

WHAT IT IS: the birthday's low-key cousin. it comes and goes with less fanfare—if any, at all.

take this opportunity to have an individual celebration. mark how far you've come and check in on your life goals if you made any at the start of your personal new year. also engage in as many small indulgences as you like:

- *something you have never done before*
- *rent a scooter and go exploring*
- *an ice cream cone with all the fixings*
- *a huge slice of cake from that bakery to carry home in its pretty box*
- *a fresh'do*
- *an umpteenth rewatch of your favorite movie of all time*
- *takeout from a local restaurant you love*
- *take the day off work*

AND if it's your child whose birthday is during the winter holidays, a time when their friends would be away with family, do the opposite: use their half-birthday to throw a party in the summer when all their friends will be around.

# you've got the house

*to yourself*

"me: unbothered, moisturized, in my lane, well-hydrated, flourishing."
—CARDI B

*"push it"* by salt-n-pepa

*"kiss"* by prince

*"good as hell"* by lizzo

*"i got you babe"* by sonny and cher

*"hey ya!"* by outkast

*"bodak yellow"* by cardi b

*"golden"* by harry styles

YES, GETTING HOME-ALONE TIME means you can watch hours of guilty pleasure tv and sit on the best part of the sofa normally occupied by the dog, the cat, kids, roommates, or partner, if you want.

but the gift of physical space can also give you the opportunity to create some space in your brain. so take this occasion to declutter, in whatever form that means for you:

- *spend hours rearranging the fridge*
- *shake it out for a few minutes with the stereo turned up*
- *surround-sound meditation*
- *reacquaint yourself with the snooze button*
- *have a closet cleanout*
- *work your way through your digital streaming list*
- *use the moisturizing face mask you've had for weeks*

# you
# picked
*(or grew, or bought)*
# "too
# many"
# apples

SPEND A DAY making, baking, freezing and infusing. dig around for a family recipe; try out a dish or two from somewhere else in the world. some of these will store well in the freezer to use as last-minute housewarming gifts and brunch add-ons down the road; others can be wrapped up with twine or ribbon and shared with neighbors, family, and friends right now.

ALSO WORKS FOR any fruit you find yourself in excess of.

# apple bunnies

"my grandmother was born in nagano, which is the second-largest apple-producing region in japan. every year during apple season, she'd get boxes filled with red apples sent to her from her hometown. whenever i'd visit her during that time she would peel and cut tons of apples into cute little bunny shapes for us every morning while cheerfully singing 'an apple a day keeps the doctor away.' apples are a moment for me to recall my grandma's smile and a small joy that i had every morning with her."

—AYAKO

she heads up kate spade new york in japan

- STEP 1: cut an apple into eight wedges and remove the core.

- STEP 2: at one end, score a shallow v-shape incision in the apple skin. just enough depth so the skin can be removed.

- STEP 3: run knife under the apple peel (just like how you'd peel apple skin normally), starting at that tip and stopping at the base of the v-shape. the excess part will come off. if not, score the v-shape incision again so it does.

- STEP 4: to prevent browning, immediately soak apple wedges in salt water for 10 seconds.

# apple turnovers *2 ways*

## MAKES 8

### FOR THE TURNOVERS:

- 1 lb puff pastry (2 sheets)
- 1¼ lb granny smith apples (approx 3 medium)
- 1½ tbsp unsalted butter
- ¼ cup brown sugar
- ½ tsp ground cinnamon
- ⅛ tsp salt
- 1 egg for egg wash
- all-purpose flour, for dusting

### FOR THE GLAZE:

- ½ cup powdered sugar
- 1–2 tbsp whipping cream

### FOR A BRIE VERSION:

- reduce butter to ½ tbsp
- swap cinnamon and sugar for 6 tbsp honey
- add slice of brie before sealing squares
- drizzle honey instead of sugar glaze
- serve with a citrusy cocktail and a side of prosciutto-wrapped melon

- preheat oven to 400°F. remove puff pastry from freezer and thaw according to instructions. peel, core, and cut apples into small chunks. in a medium pot, melt butter over medium heat. add apples and cook until softened (around 5 min.), stirring occasionally. reduce heat and stir in brown sugar, cinnamon, and salt. simmer until apples are soft and caramelized. remove from heat and set aside to cool.

- roll out each sheet of thawed puff pastry into an 11" square. cut into 4 equal squares. (8 total.) place apple mixture in the center of each, leaving a small border of pastry.

- whisk egg and a small splash of water to create an egg wash. lightly brush egg wash around pastry edges, then bring opposite corners together to create a triangle shape. tightly crimp edges to seal.

- place sealed turnovers on a parchment-lined baking sheet. with a sharp knife, cut 2–3 small slits across the top of each (this reduces filling leaks) and brush on remaining egg wash.

- bake until pastry is puffed and golden, about 20–25 min. you'll see a little filling leakage during baking.

- while turnovers are warm, mix powdered sugar and whipping cream and drizzle over turnovers. finish it off with a scoop of vanilla ice cream.

### HOW DO YOU LIKE THEM APPLES?

applesauce. almond cardamom cakes.
äppelkuch. bread pudding. brown bettys.
butter. chutneys. charoset. cheese scones.
cider. cider donuts. cinnamon bread.
cobblers. crisps. dumplings. empanadas.
eve's pudding. flavored vodka.
french apple cake. fritters. galettes.
ginger crostatas. jam. jelly. maple
upside-down cakes. pandowdies. pies.
pies in a jar. sauerkraut. sausages.
sharlotkas. strudels. tarts. tarte tatins.

# we've got something in common

WHILE MOST OCCASIONS revolve around friends, family, and coworkers, sometimes you want the whole town in on the game.

maybe it's about coming together out of a shared curiosity to learn more about each other's life experiences and cultures, or ones beyond your borders. other times you could all be rallying behind the same greater good. here are some ways to grow your community circle:

# fundraisers

- organize a cheap-and-cheerful ticketed meal at your place, or the local school or town hall. (tip: pile the desserts high and put them somewhere everyone can see right when they walk in. watch ticket sales spike.)

- pool preloved treasures in a multifamily garage sale that spans a stretch of city sidewalk or a collection of neighborhood driveways.

- take over an area parking lot to host a tailgate bingo night. monetize the cards and daubers, rent out the folding tables for a fee, and let guests bring their own snacks.

- phone bank and chill. invite the community over to campaign for a favorite cause or politician.

- start an a cappella group. sing your hearts out for tips and donate to a beloved local cause.

- host a skill-share auction; participants donate their know-how, which is bid upon live or online; the more eccentric the menu of aptitudes, the better (bike tune-ups, merengue lessons, calligraphy, dog-walking, résumé editing, floral arranging, tarot card reading).

ESPECIALLY GOOD FOR schools, children's clubs, social causes, and any organization, family, or individual who could use a little extra support from people who want to pitch in and help.

## bridge-builders

- move your backyard meal to the front lawn or local park to encourage friendly drop-ins.

- coordinate a seasonal series of swap meets: books, toys, clothes, albums, tools.

- organize volunteers to tend to a community garden; start a compost area for everyone to use.

- lead an annual neighborhood tradition. think: block party, street dance with live music,or tasting tour, where locals set out food to share on their porch, lawn, or stoop. you never know what cuisine, family recipe, or personal invention you might discover.

- start a book or film club fueled by curiosity: other cultures, other traditions, each other's cultures and traditions.

- organize a week's worth of home-cooked dishes and delivery gift card meals for new parents, neighbors under the weather, and anyone else you know who could benefit from a well-stocked fridge.

- do a ding-dong ditch. quietly leave a gift on your neighbor's doorstep—donuts in a pink bakery box, a potted plant, a handwritten note—to congratulate or cheer someone on. let your kids (or your inner kid) ring the doorbell and run.

our communities are wherever we find them. they get closer whenever we extend the invitation.

# *a progressive*
# lunch, dinner, or party
# in your neighborhood

...........................................................................................................

- **DESIGNATE** an annual event and have it on the same day every year. (e.g., the third saturday in july, the wednesday before thanksgiving. maybe both.)

- **FIND OUT WHO'S IN**. join forces with one or two people can help spread word quick.

- **CHOOSE THE ORDER** of homes and assign an hour to each location. make sure whoever is last likes the idea of guests that stay awhile.

- **LET EACH HOUSE CHOOSE A THEME,** plus one easy food item and one signature cocktail to serve. (some advice: come to a neighborhood consensus on a single liquor you'll all base your drinks on. trust us.)

...........................................................................................................

maybe you'll choose a jordanian theme because those are your family roots. maybe you make your delicious kunafa and fresh pomegranate juice topped with sugary froth.

maybe the next house will be all *monsoon wedding* because they just watched the film with their daughter last week. maybe they serve homemade missi roti, gulab jamun, and spiked lassi of all kinds (mint, mango, lime . . .).

as the energy of moving around to different houses picks up speed, you may discover that your local friend circle just got a little bit wider.

# you potty trained your child

IT'S A PRETTY FUNDAMENTAL LIFE SKILL, teaching someone to let go of $%&!. they're learning to listen to their body.

*is it a big deal?*
*should i hold it in?*
*should i say something?*
*can i wait it out?*
*what matters?*
*what doesn't matter?*

these are very important questions to be able to answer for oneself in life.

on their way to enlightenment, some actual, tangible rewards are going to be appealing. reframe them in your mind not as bribes but as gifts: the exchange of a successful potty for a present is your occasion to show this little person that you care about their well-being. so don't just resort to the usual things that have worked for everyone else: the most meaningful rewards will be ones that make your unique child feel cared for, loved, and appreciated for their contribution.

## congratulations

you have set them in motion to be independent in more ways than one.

# reach for the stars

WAYS TO REWARD THEIR POTTY PROGRESS BY THEIR ZODIAC SIGN.

### ARIES

to this prize-loving sign, a big clear jar labeled "potty prizes" filled with colorful toys, placed in eye's view, will be very tempting.

### TAURUS

they love feeling appreciated so tell them how much their new skill helps the family. they also love to dress up, so let them choose big-kid underpants as a treat.

### GEMINI

reward them with dance parties to their favorite songs, and hands-on toys. musical instruments are good. (avoid drums.)

### CANCER

picking out creative supplies each time—stickers, a coloring book, a picture book from the library— will keep them motivated.

### LEO

heap on the praise, and consider prizes involving animals: visiting their neighbor's puppy, visiting a petting zoo, stuffed animals. leos have a natural caregiving streak.

### VIRGO

they love a goal. let them rack up points or stickers toward a larger prize, then give them the option to choose when the time comes.

## LIBRA

write down your toddler's favorite activities. let them choose one after each success and do it together. they value special one-on-one time.

## SCORPIO

they like having "favorites." make a list of things, people, foods, and activities they love. choose one to do, make, or hop in the car to go see, with each success.

## SAGITTARIUS

these animal lovers adore pets and stuffed animals, so take them to a local farm or give them books with wildlife characters.

## CAPRICORN

reserved and quiet, they like solving problems on their own. let them know you're always available for help if needed, and that a trip to the park is waiting.

## AQUARIUS

give them something they can look forward to, like letting them choose anything they want (within reason) for dinner that night.

## PISCES

this comfort-loving sign adores the smell of chocolate chip cookies and apple pie in the oven. let them help you with cooking and baking.

# you crushed that fear

WE COME FACE-TO-FACE WITH FEARS of all shapes and sizes (real and self-induced) every day. some are obvious and immediate (dating apps, skydiving, public speaking, spiders) while others are more subtle and introspective (intimacy, being alone, asking for what we need). whatever lies outside of our comfort zone, the moment we are able to switch from *i see you,* to *i see beyond you* and take the leap beyond our fear is cause for celebration.

there's courage* in putting yourself out there. you might, after all, totally fail. but the reward, an emotionally braver you and maybe a new skill to boot, is worth the risk. in moments like these, here's a life-balance motto we really get behind:

## do something hard. then do something fun.

funnily enough, anxiety and excitement come from the same part of the brain.

* *the root of the word "courage" is "cor," the latin word for heart. over time the word has evolved in meaning. courage originally meant "to speak one's mind by telling all one's heart."*

*or*
*you could also choose*
*to celebrate the process*

"i'll buy a piece of jewelry and wear it until that moment i'm going through has passed," says kristen, who heads up our ideation studio and wears her courage like treasure that's shaped the person she's become. "typically it's a life change. in my 20s it was a ring. i was struggling to pay for school, and i thought 'i'm going to buy this ring and wear it until i graduate.' i ended up wearing it for ten years. my gold bangles; bought them when i was going through a divorce and i still wear them. they're both brass, which has properties around courage."

### CHOOSING DECORATIVE ARMOR

hippocrates wrote that silver had beneficial healing properties. choose sterling silver for patience and perseverance, and to deflect negativity.

ancient egyptians ingested gold for mind, body, and spirit. skip that, and instead wear it to ease tension and anger, bring comfort, and encourage your potential.

copper is good for emotional focus. it's stimulating and revitalizing.

# it's your *dog's* birthday

WILL THEY UNDERSTAND WHAT'S HAPPENING? not a chance. this is your excuse to have a funny theme party. prepare to get silly.

(in all seriousness, though, since they are the one family member who's always excited to see you, who entertains the in-laws when they visit and accepts blame for all types of things from missing homework to messy rooms, you could also spend their day doing things you two love doing together. but back to the party . . .)

*happy birthday, fido.*

AND if it's your cat's big day: treat them to a little catnip, cat naps, playtime, and grass-fed steak. they're not quite the party animals dogs are.

THE INVITATIONS:
- gather your friends, family, and neighbors and their dogs.
- is it BYOB? (bring your own bone.)
- opt for donations in your pup's name to a local animal shelter, adoption or rescue group in lieu of gifts.

THE PLAYLIST:
*"who let the dogs out"* by baha men
*"atomic dog"* by george clinton
*"black dog"* by led zeppelin
*"dog years"* by maggie rogers
any original snoop dogg

DECOR:
- themed helium balloons.
- individual water bowls for each furry guest with names written on the side.
- photo wall. dress up supplies (for all) encouraged.
- if it's summer, put kiddie pools full of water in the lawn to keep the dogs cool.

GAMES:
- bobbing for bones • toy toss • scooby says • tug-of-war

THE (DOG) MENU:
- a bark–cuterie board of assorted treats • pupcakes

THE (HUMAN) MENU:
- hot dogs and hush puppies
- boneschetta (bruschetta using bread cut with a dog bone–shaped cookie cutter)
- chocolate bark

PRIZES:
*"the shaggiest guest"*
*"the best-dressed guest"*
*"the best-behaved guest"*

QUICK POINTERS:
- consider not having any small children there, or have a separate area for them.
- if the party's at home, make sure the yard or indoors is pet-friendly (valuables and breakables out of sight) and pet secure (fences and doors).
- get the birthday dog a pawdicure beforehand.
- don't forget the milestones: **13 dog years**: bark-mitzvah, **16 dog years:** sweet 16
- at the tail end of the festivities, send guests home with goodie bags filled with dog bones and rolls of poop bags in fun colors. (you can never have enough.)

CYNTHIA ANDREW IS A BROOKLYN, NY–BASED ATTORNEY, FASHION-TRAVEL BLOGGER, AND NEW MOTHER OF TWINS, WHO SETS OUT TO LIVE EVERY DAY COLORFULLY. SHE HOSTS LATE-NIGHT VIDEO CHATS WITH HER CLOSEST FRIENDS TO CELEBRATE EACH OTHER'S WINS, AND TAKES ANTIHISTAMINES WITH HER TO PARTIES IN THE HOPE THAT THERE WILL BE GRILLED SHRIMP, EVEN THOUGH SHE'S ALLERGIC.

people think you can only celebrate
having a baby or a wedding.
you need to acknowledge you completed
a task no matter how small it is.
you finished something on time,
you made it through your to-do list,
you resolved some things you needed to
resolve, you finalized something—
take 5 minutes and sit in that moment.
life is so fast that slowing down
and enjoying it is the celebration.
if you can't see reasons to celebrate
yourself, celebrate people around you
and make them feel good.

—CYNTHIA ANDREW

# you're finally watching that movie *(or tv show)*

THREE SCENARIOS AND ONE THING FOR CERTAIN: prepare yourself for an active viewing experience. lights, camera . . .

# conversation circle

one of the most powerful things you can do for yourself is admit when you don't know something. celebrate curiosity, and the ways this experience might help you think differently or more expansively.

SET THE SCENE:
- create a space with a couple of close friends or family to watch a documentary or film that delves into human rights issues or depicts an underrepresented group. (for instance: *the thirteenth, schindler's list, an inconvenient truth.*)

- as a prologue to the evening, send a resource list on your invite with key essays or reporting on the topic for your guests to read.

- as an epilogue, queue up clips of cast interviews to watch, to deepen the experience.

# private screening

ideal for the things your coworkers have seen and your friends quote and meme, but you just never got around to watching. until now. before you settle in and turn the lights down low, do a culture deep dive: listen to podcast episodes and interviews with authors, directors, and cast. read cultural analysis essays.

SNACK PREVIEW:
- **matinee:** a tray of dream cinema concessions: small bottle of bubbly, at least two kinds of popcorn, good dark chocolates.

- **evening:** order food delivery. somehow, the simple act of eating takeout on the sofa while watching a movie always feels like a party.

# theme party

survey your friends: who hasn't seen it? who has seen it and wants to rewatch? gather them together and thread iconic elements from the film or show into every moment of the night. (you may also learn some show backstory in the process that will come in handy for planning some post-viewing games.)

DIRECTOR NOTES:
- send an invite. a GIF-ing photo from the film or show makes for a fun email backdrop or text message header.
- everyone's dressing up, and yes, it's mandatory to some degree.
- make a meal of it.
- create some friendly competition.

finally watching *schitt's creek*?

- text your friends. open with a david rose meme.
- source black-and-white ponchos (david's favorite) that can double as blankets, and moira rose wigs for everyone to wear.
- serve vodka out of the freezer and cheap wine alongside enchiladas with the cheese "folded in."
- for a drinking game, a sip every time moira admonishes, *"jossalynnn."* after the show, pop quiz!
- have goodie bags with one very carefully selected tube of lip balm placed inside.

GET FANCY WITH THE POPCORN:

- **popcorn arancini:** roll popcorn and melted mozzarella bite-sized balls.
- **popcorn nachos:** drizzle plates of popcorn with cheddar cheese, bacon, sour cream, and chives.
- **popcorn s'mores:** roll popcorn, chunks of chocolate, melted marshmallows, and tiny pretzels into bite-sized balls.

## have you seen these?

IF THE ANSWER TO ANY IS "NO,"
THIS IS YOUR OCASSION TO.

- O four weddings and a funeral
- O amélie
- O she's gotta have it
- O sex and the city
- O selena
- O dirty dancing
- O downton abbey
- O clueless
- O volver
- O bridget jones's diary
- O the thomas crown affair *(original)*
- O poetic justice
- O bridesmaids
- O paris is burning
- O working girl
- O love actually
- O breathless
- O monsoon wedding
- O veep
- O when harry met sally
- O thelma & louise
- O the wire
- O fleabag
- O transparent
- O insecure
- O booksmart
- O in the mood for love
- O parts unknown

COSMOS
for birthdays,
weddings,
everyday luck
and support

PINK
CARNATIONS
for mother's day,
love, admiration

# occasion

BECAUSE BEAUTIFUL FLOWERS

ZINNIA
for going-aways,
welcome-homes,
and friends

GARDEN ROSES
there's a color
for every occasion

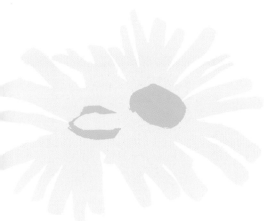

DAISIES
for all kinds of
new beginnings

ANTHURIUM
for housewarmings,
graduations, hostess
gifts, love

# flowers

BRIGHTEN A MOOD LIKE NOTHING ELSE.

PEONIES
for anniversaries,
romance, happiness,
good luck

SWEET PEA
for thank-yous

DAHLIAS

ANEMONE

*joyful*
# anytime

DAFFODILS

QUEEN ANNE'S
LACE

RANUNCULUS

HYDRANGEAS

# flowers

"color is a power which directly influences the soul."
—WASSILY KANDINSKY

BLACK-EYED
SUSANS

FRENCH TULIPS

*on the first day of*

# sprin
# sum
# fall, w

# g, mer, inter...

# spring PARTY IN THE PARK

MAYBE IT'S WARM WHERE YOU ARE. chances are, it's not. but after a season indoors (stir-crazy, anyone?), bundle up and head outside. it feels like fall, in reverse. everything is about to blossom.

*date:* march 20

*time:* 4 p.m. (movie starts at dusk)

*location:* a nearby park or community garden or your backyard

*one more thing:* bring headphones and download the streaming app

## SCREENING LOGISTICS:

- hang a sturdy, oversized white sheet from a clothesline.
- get a mini projector you can connect your phone to.
- choose your movie: the trick is to pick something that's either sharp and funny, very extra, or iconic and visually gorgeous. nothing longer than 100 minutes. *the grand budapest hotel*: yes. *casablanca*: no.
- to maximize sound and minimize disruption, use headphones and individual speakers: have everyone run the film you're playing from a shared streaming app on their phones. think silent disco.
- hire a babysitter to create games for the kids when they start getting antsy.

## ON AND AROUND THE TABLE:

- focus the food and drink around one large picnic table somewhere within eyesight but away from the screen. pile the food high, stock colorful pails with ice, and add mini bottles of champagne, beer, and soda, and let everyone help themselves.
- for meal- and movie-time, cluster plaid picnic blankets and oversized floor cushions in front and scatter theater-sized boxes of candy on them for mid-movie dessert.
- bring some extra blankets in case people get chilly.

## ON THE MENU: fried chicken • macaroni and cheese with smoked gouda, cheddar, and parmesan • coleslaw • buttery biscuits • chocolate chip cookies • champagne, beer, and soda • vodka-spiked pink lemonade

the most thrilling day of the year,
the first real day of spring
had unclosed its warm delicious
beauty even to london eyes.
it had put a spangle in every colour
and a new tone in every voice,
and city folks walked as though they
carried real bodies under their
clothes with real live hearts
pumping the still blood through.

—KATHERINE MANSFIELD,
*the garden party and other stories*

# summer BBQ & DRINKS ON THE ROOF

SUNGLASSES. FULL GLASSES. TIME TO PUT THINGS ON ICE TO CHILL. this is the season when everything is lightest and brightest, and even flavors taste best at their extremes.

*date:* june 20 (if that falls on a friday, even more apropos)

*time:* 5 p.m.–ish, to catch the golden hour

*location:* rooftop

*one more thing:* wear a bathing suit somewhere in your outfit. summer isn't just a season. it's a mindset.

FOR THE TABLE: black-and-white gingham tablecloth • bright red cloth napkins • white plates • a series of mini cacti down the center boasting various colors of tiny blossoms • colorful folding chairs • votive candles

## ON THE PLAYLIST:

- *"vintage music no. 130-lp"* by noro morales
- *"i like it"* by cardi b
- *"bam bam"* by sister nancy
- *"every little thing she does is magic"* by the police
- *"the girl from ipanema"* by amy winehouse
- *"put your records on"* by corinne bailey rae
- *"is this love"* by bob marley & the wailers
- *"hungry heart"* by bruce springsteen
- *"dancing in the moonlight"* by king harvest

## ON THE MENU:

- toasted tortillas alongside a smorgasbord of unexpected toppings that play well together on top: fried eggs, grilled shrimp, italian sausage. kimchi, coleslaw, sliced roasted potatoes, pickled onions, avocado slices, roasted tomatoes, crushed peanuts, sriracha mayo, parsley, lime wedges
- for dessert, grilled plantains drizzled with honey, topped with ice cream
- big bowls of juicy red strawberries
- ice-cold beer, pineapple sweet tea
- thunder in paradise, shaken not stirred

# THUNDER IN PARADISE

......................................................................................

you might be thinking: sherry? really? but this drink is pink. it's
got coconut. you will want more than one. this tiki-style cocktail
is like the sophisticated piña colada you never knew existed but
secretly wished did.

......................................................................................

shake 1 ½ oz rum, ½ oz sherry, 2 oz simple syrup, ½ oz almond orgeat
syrup, ¾ oz fresh lime juice, and ¾ oz fresh cream of coconut with ice
and strain into a glass filled with ice. add bitters.

# fall PATIO BRUNCH

EVERYONE'S BACK AND GETTING BACK TO IT. get together to savor the bright blue skies, crisp air, some lingering warmth from the sun, and a messy mash of comfort foods before you all blink and it's winter—because that's going to happen.

*date:* september 22

*time:* late morning

*location:* your atrium, garden, kitchen table, or back patio

*what to wear:* an easy dress and a big, cozy scarf

## FOR THE TABLE:

- the biggest wood or marble brunch board you've got (or a few platters and trays) to run down the center of the table. you'll put all of the food on these.
- bright white plates and brightly colored glassware
- napkins in pretty patterns and colors in fabric sourced from your local fabric store
- garden roses galore loosely mixed with wildflowers

## ON THE BAR CART:

- all the fixings for lillet blanc spritzers
  (lillet blanc + tonic + a squeeze of orange over ice)
- rosé champagne
- ice bucket of fresh fruit-juice ice cubes to pop into glasses of sparkling water
- pitchers of water with slices of fresh cucumber, mint, and grapefruit

## ON THE MENU: assemble an overflowing seasonal board of: seeded toasts • hard-boiled eggs, cut in half • smoked salmon • fresh apricots, cherries, lemons, figs • avocado wedges • thinly sliced red onion, cucumbers, radishes • celery • cherry tomatoes, halved • basil pesto • pitted green olives • capers • cream cheese • honey • fruit jams • fresh basil, dill, mint, and chives, roughly chopped and put in tiny bowls • burrata cheese

*side notes:* prep all the vegetables and lay the table the night before (especially the boiled eggs). pull the eggs, burrata, and cream cheese out of the fridge 30 minutes before serving.

> **"**
>
> life starts all over again
> when it gets crisp in the fall.
>
> **"**

—F. SCOTT FITZGERALD,
*the great gatsby*

# winter AN IT'S-NOT-A-PARTY PARTY

THE SEASON HAS JUST BEGUN, but "the season" has been in full swing for weeks. give everyone a break from dress codes and small talk to martini and chill. (you know they're going to wind up on the dance floor eventually regardless. they always do.)

*date:* december 21

*time:* 7 p.m.

*location:* your living room, which is now also a dance floor

*one more thing:* mother nature's bringing twinkling stars. how about you bring vodka?

ON THE BUFFET TABLE: a bright, festive runner • stacks of red, gold, black, and white patterned china • gold silverware • bunches of french tulips in crystal bowls • crisp white napkins tied with black grosgrain ribbon

AROUND THE ROOM: turn off stark overhead lights, string up fairy light garlands, turn on low lamps, and lean into things that sparkle. blow up metallic balloons and affix them upside down from the ceiling at various string lengths.

AT THE DIY MARTINI BAR, ALL THE ACCOUTREMENTS FOR: gibson with a cocktail onion • an appletini with apple juice and a crisp slice of granny smith • lychee martini • cape cod with cranberry juice • classic martini • dirty martini

A GET-THEM-DRUNK-AND-MAKE-THEM-DANCE PLAYLIST:

- *"i melt with you"* by nouvelle vague
- *"home to you"* by cafe le bon
- *"she's a lady"* by lion babe
- *"heaven is a place on earth"* by belinda carlyle
- *"hips don't lie"* by shakira
- *"say my name"* by destiny's child
- *"kiss"* by prince
- *"everybody wants to rule the world"* by tears for fears

ON THE MENU: smoked salmon and crème fraiche on black bread • individual cups of fettuccine topped with caviar • DIY ice cream sundaes served straight up in martini glasses

# THE perfect MARTINI

include a stack of cocktail napkins nearby printed with with your address in bold lettering. these will come in handy at the end of the night when everyone starts ordering cabs. keep the vodka, gin, and even the glasses in the freezer till your first guest arrives, so they're frosty.

mix 3 oz gin, a splash of vermouth, and an olive or cocktail onion to garnish.

seat someone
shy next to
someone flirty.

# table

have at least
one extrovert
at every table to
spread the fun.

cheesecake
for 20 will
actually feed
10.

informal and
plentiful
is more inviting
than rigid
and sparse.
(this applies to
all things. not just
the table.)

a little
spectacular and
very delicious
is more impactful
than familiar
and safe.

courses to
a meal
cadence out
a night
really well.

# 3 truths

more than
8 people
around a table
will end
conversations
before any
even start.

think of
flatware and
glassware
as jewelry for
the table.

it's a feast

PURCHASE A SHOPPING CART'S WORTH of fresh roma tomatoes, yellow onions, garlic, coriander, turmeric, and red chilis. invite your extended family and some friends over to share in both the labor and the spoils. provide all the tools, pack everyone into a kitchen, and give them a job: chopping, slicing, grinding, stirring. (tasting: that's everyone's duty.) this is not just about making curry. this is about talking for hours while your hands are busy.

but this all-day extravaganza will result in enough curry sauce to last everyone present an entire year. package most of the results into portable freezer containers. portion enough aside for an immediate group dinner, then roast some crispy potatoes, steam various veg, toss some huge salads. pile plates and bowls high. like the sauce, none of these are single-portion servings: everything can be spread across more plates than you planned if unexpected guests arrive.

creating something together is the kind of time-consuming activity that unites and reaffirms that yes, we really like each other.

call it *your annual sauce day*

you can also get saucy with marinara, peri-peri, or chili. there are lots of variations on this theme. here are a few more . . .

*legend has it, cleopatra bet mark antony that she could throw a more extravagant feast than he could; to one-up him, she ate a precious pearl.*

## tamale day

one of our team members' cousins-in-law hail from a big mexican-american family in east L.A. when the cousin's great-grandmother immigrated to los angeles from northwest mexico in 1950, she started a cooking-and-eating tradition for the women in her family: a day of tamale making.

8 A.M.: the women and girls in the family gather at the godmother's house. "tamale making is a female-only tradition in our family," the cousin explains.

8:30 A.M.: each guest chooses a task, then takes a seat at the long row of tables piled with ingredients.

UNTIL 5 P.M.: after working in assembly-line form preparing 400 tamales, the women divide a bunch of tamales among the families to share with friends, coworkers, and neighbors.

NEXT DAY: the elder women cook the tamales they saved to serve that night.

# *lita's* tamale recipe

## MAKES A LOT

- 4 large packs of hojas (corn husks)
- 20 lbs pork cushion meat
- salt, pepper, cumin
- 8 cloves garlic
- 2 bags pasilla chile pods
- 2 slices white bread, toasted
- 2 large yellow onions, thinly sliced
- flour
- 15 lbs masa (dough)
- 5 lbs lard
- 5 lbs potatoes, peeled and thinly sliced
- 3 large zucchini, sliced into fries
- 4 lbs green beans, ends removed
- 4 lbs yellow chile peppers, cut into quarters and seeds removed
- 8 tomatoes, cut into thin wedges

- soak hojas in water.

- **prepare pork:** cut pork into medium pieces and place in a large pot of boiling water. add salt, pepper, garlic cloves. boil for about 3 hours, skimming excess fat. you'll know it's ready when you can pull the pork apart with a fork. set aside broth. shred pork.

- **prepare chile sauce:** remove all seeds and stems from pasilla chiles. place in blender with toasted bread and a handful of sliced onions. fill blender to the top with broth. add salt, pepper and cumin to taste. pour into large pot. bring to a boil and add flour to thicken. you don't want it soupy or watery.

- pour some sauce onto pork and cook until it boils. add more broth only if needed. you want the pork to be covered in sauce, but not runny. add salt for flavor. bring to a simmer.

- **prepare masa:** add masa to a large, deep pot. add 2½ lbs lard. add some pasilla chile sauce and knead with your hands. masa should be light orange in color. (ps: if your hands are oily after mixing all these ingredients, then you added the right amount of lard.)

- **prepare vegetables:** boil potatoes, zucchini, and green beans in separate pots until tender. drain. pour each into a separate container and place in location where tamales will be assembled.

- **prepare hojas:** remove from water. clean and dry completely. separate big from small. (small hojas are used to tie the ends of tamales. shred these into thin strips.)

- **assemble tamales!** lightly spread masa evenly over a wide hoja. add spoonful of meat in the center. add vegetables on top, to your liking. wrap tamale and tie at each end to prevent ingredients from coming out. if you're unable to get the tamale closed, add another hoja covered in masa to cover it. if needed, you can also tie the middle of the tamale to help keep it closed. every tamale is unique and they won't look the same.

- **cook tamales:** add water to the base of a large stock pot that has a steamer insert. add spoonful of salt. add steamer and place tamales on it, straight up. cover tamales with leftover hojas and place a wet kitchen towel on top of those hojas. steam 40 min to 1 hour on low heat or until masa is cooked.

*disclaimer:* this recipe was handed down by my grandmother without any measurements. every ingredient was measured by her hands, her taste, and lots of love!

# thirty-two kinds of savory stuffed dough

- samosa INDIA • ravioli ITALY • pierogi POLAND
- mandu KOREA • knish ISRAEL • empanadas ARGENTINA • cornish pasty ENGLAND • pelmeni RUSSIA • nom pao CAMBODIA • stromboli ITALY
- maultaschen GERMANY • shish barak LEBANON
- pasteles PUERTO RICO • patties CARIBBEAN • mas paan SRI LANKA • gyoza JAPAN • tyropitakia GREECE
- cha siu bao CHINA • bakpao INDONESIA • bánh bao VIETNAM • momo TIBET • pirukas ESTONIA
- khachapuri GEORGIA • coxinhas BRAZIL • manti TURKEY • yomari NEPAL • knödel CZECH REPUBLIC
- kroppkaka SWEDEN • pastizzi MALTA • rissóis PORTUGAL • vareniky UKRAINE • gougère FRANCE

69

# *multi-generational* potluck*

one of our copywriters' extensive vietnamese-american family all get together at a relative's house at least once a year for a feast. it's a chaotic potluck, a medley of traditional vietnamese cuisine, french delicacies, and cosmopolitan shortcuts with plenty of wine and conversation in mixed vietnamese and english. the menu varies year to year, but each family member is assigned a dinner item, and the flow goes something like this:

*a "potluck," in which invited guests bring a dish to share at a communal meal, comes from 16th-century english "pot-lucke," in which unexpected guests made do with whatever was already cooking in the pot.

## aunt 1: TRADITIONAL STARTER

you'll find the second-oldest sibling at the stove, deep-frying her homemade cha gio, vietnamese spring rolls of thin rice noodles, mushrooms, ground pork, and fresh herbs wrapped in soft rice paper. crispy hot from the pan. dipped in fish sauce. a crowd favorite and a staple from their generation's childhood in hanoi.

## aunt 2: INDULGENT MAIN

lobsters thermidor is her specialty, cooking the meat in a rich wine sauce, then stuffing it back into the shell for browning. (that week, special-occasion shellfish was on sale at her fish market.) she also plates one-pound blocks of foie gras and paté (vietnamese cuisine is influenced by the french, who colonized the country) with an assortment of crackers.

## aunt 3: WINE

our writer's mother arrives with a case of central california coast reds from the vineyards she visits. the bottles get sampled before and during dinner in mismatched glassware.

## quiet uncle: GRILL DUTY

he's french-trimming racks of lamb or beef tenderloins that have been marinated in garlic and scallion sesame-soy, then watching over their outdoor cooking while nursing a cognac.

## chatty uncle: DRINKS

not a cook, contributes bottled waters and sodas.

## cousins: SIDES

an artist cousin with a new hobby of growing mushrooms brings a cucumber carrot herb salad with a spicy vinaigrette, while her brother blanches asparagus with a squeeze of lemon and sea salt or roasts a root veggie, depending on the season. their younger sibling opens up big bags of crispy chips and tins of salted nuts.

## hosting aunt: DESSERT

something elaborate from the french bakery near the host's home: an opera cake, a fruit custard tart, or maybe individual crème brûlées, the late grandmother's favorite. plus a box of fancy chocolates, because options.

## the big
## cookie bake

another coworker of ours grew up sampling her mom's annual cookie bake. van (a.k.a. mom) would invite friends and office favorites to come with one or two batches of premade raw cookie dough and an empty cookie tin. the group then spent all day taking turns baking their batches, sharing mom's oven, along with tales from work and spoons of uncooked batter.

AT THE END OF THE DAY,

everyone filled their own tins with a few of each baker's cookies. mom's own recipes differed from year to year, but her peanut butter drops with a chocolate kiss were a consistent favorite.

FAST FORWARD TO TODAY.

our coworker doesn't have space in her new york kitchen for more than two bakers at a time, so she hosts a chocolate dipping party:

AMENDED
GUEST LIST:  two friends and their children, plus her own children.

RECIPE:  melt dark chocolate chips in a double boiler and dip into it whatever sounds good that day: strawberries, marshmallows, gummy worms, potato chips, pretzels . . .

THE YIELD:  a smorgasbord of homemade to pile into empty take home containers.

# *Van's* peanut butter chocolate kisses

## MAKES 60

- 2⅔ cups flour
- 2 tsp baking soda
- 1 tsp salt
- 1 cup butter
- ⅔ cup good peanut butter
- 1 ½ cup granulated brown sugar, plus extra to roll cookies in
- 2 eggs
- 2 tsp vanilla
- 1 bag chocolate chips

- sift together flour, baking soda, and salt into a bowl. beat together butter and peanut butter in another bowl. add sugar and beat well. mix in eggs and vanilla, then add the sifted dry ingredients and combine thoroughly. chill dough for 1 hour.

- shape dough into 60 balls. roll them in granulated brown sugar and place on ungreased cookie sheets. bake in a preheated 375°F oven for 8 minutes. remove from oven and press a few chocolate chips on the top of each cookie. return to the oven and bake for 2 minutes more. cool on racks thoroughly before storing.

# you learned how to play the guitar *(and wow, you're good)*

INVITE PEOPLE OVER for a nondescript, low-key cocktail hour,* where you're the surprise entertainment. after their first round of drinks are down (or whenever you've worked up the chutzpah), casually pick up your guitar and ask if they'd like to hear a song.** if you mess up, remember: no one expects an amateur to be jamming with joan jett after a few lessons, so release the pressure valve.

*once you've practiced till you can't stand your song(s). **start with the easiest one first.*

# playing to everyone's talents

A FEW YEARS AGO, a friend of ours ditched the registry for her wedding and requested guest performances. (yes, as in performances by her wedding guests.) attendees were tasked with showing off their skills—some seasoned, some amateur—for the new couple. it made the reception unique, interactive, and memorable.

turn your debut performance into an occasion to showcase a few more hidden talents in the group. there's a level of vulnerability in showcasing amateur skills—getting more people in on the act can do wonders to calm jitters. butter a couple of friends up to doing something to kickstart or cap off your gathering. nudging someone for an impromptu party trick in the moment works, too. it might just turn it into a full-fledged talent show of:

- hand-clapping routines
- book reading (pick a passage. any passage.)
- portrait sketching
- line dance leading (someone's gotta be at the front)
- tarot card or palm reading
- improv
- magic tricks
- dance moves
- cocktail mixing (a dramatic tall pour or shaker flip will slay)

if you need inspiration to make the ask, or reveal your own hidden talent, just watch these:

- the karaoke scene in *my best friend's wedding*.
- the living room marionette show (and yodeling) in *the sound of music*.
- the dinner party lip sync in *beetlejuice* to harry belafonte's "day-o."
- multiple moments in *napoleon dynamite*: novice cake decorating, photo booth art directing, portrait sketching, and the class assembly's dance to jamiroquai's "canned heat."
- shirley maclaine's impromptu burner—"'i'm still here' in d-flat," as she requests—atop a grand piano in *postcards from the edge*.
- season 1, episode 6 of *the marvelous mrs. maisel*, in which the budding comedienne does a bit at a parlor room pizza party perched on the back of an emerald velvet couch.

# just because

"if i ask someone, 'why do you do that?'
and they say 'oh i think it's fun,' that is, to me, a good answer."

—FRAN LEBOWITZ

IF YOU SUDDENLY have the urge to get people together, no (official occasion is as good a reason as that. think of the wild cocktail party in holly go lightly's cramped new york city apartment in *breakfast at tiffany's*: there's absolutely no reason for that many people to be in that tiny space. yet, everyone is just having so much fun.

## do a little planning

a search for historical events and occasions can set your date and inspire your plans:

FEBRUARY 29, 1933:   nina simone's birthday. cocktails with her *high priestess of soul* album on repeat.

JUNE 2, 1946:   the first bikini bathing suit debuts in france. pool party.

OCTOBER 6, 1889:   thomas edison shows the first motion picture. dinner and a movie in the backyard.

## or do it at the last minute

new yorkers love their bodegas. yes, they're convenient; there is one on almost literally every corner. but that's not the only reason why. inside, we find little gourmet delights, drinks and snacks all dressed up in chic packaging—and can count on a specialty dish at the deli counter that may in fact be a prized family recipe. all of this is really helpful when you decide to have people over at the last minute and your fridge is empty.

SOME OF OUR FAVORITE FINDS:
- tea lights bought by the hundred to put on the table
- ice cream sandwiches picked up in the frozen aisle for dessert.
- cake mix so the kids can have a party in 20 minutes.
- spiced nuts. as appetizers. as take-home gifts.
- shiny, foil-wrapped deli sandwiches.
- bright flowers to place in dramatic vases.

*if you forget anything you can always run back.*

# it's your ~~anni~~ arrive-versary*

"you're never alone in new york . . . the city is your date."
"you're dating the city?"
"for about 18 years. it's getting serious. i think i'm in love."

—CARRIE BRADSHAW & CHARLOTTE YORK,
*sex and the city*

YOU MET. YOU LIKED EACH OTHER INSTANTLY. maybe fell a little in love: you had so much in common. you found a home, settled into a routine, started traditions. it gave you that space you needed to cross some big ideas off your checklist and starkly reminded you when you spent too much on takeout.

it defines so much about how you move through every minute of your day that the city you live in might very well have become one of your very good friends. it might even be the love of your life.

whether it's your 1st anniversary or your 21st, here are some ways to celebrate:

- take a walk along a memorable route.
- post a caption-sized ode to your city on instagram alongside a photo of a favorite moment, place, or thing.
- give something back. volunteer your time with a local cause or community space that is making the city better for all.
- if you share your anniversary with others (maybe you moved with friends from college, or with your partner), organize a dinner at your favorite restaurant. solo? take yourself out for dinner.
- if you've been somewhere for a while and now have kids, hop in the car and take them by some of your personal historical spots. (if you happen to have a wild story to share that they haven't heard before, the glimpse into young you will get their attention.)
- write a love letter to your city to reread on your next anniversary.

*the day you made it official with the city you live in.

february 2021

dear new york,

spring is in the air. do you feel it?

we feel it. we're feeling a lot these days, and we want you
to know that we love you more than a bacon egg and cheese after
a night on the town.

without you, we'd feel like a lucy without her ethel. a bloody
mary without its garnish. a poodle without her rain shoes. we just
wouldn't be us.

we love your electric energy. your almost type-a need for
organization and your chaotic creativity.

we love the sounds of your voices. the color of your taxicabs,
the way you wear your street signs, your honk-like laugh. we still
get a flutter of excitement every time we see your skyline, just
like we did on the day we met.

we love that you hold the subway door open when you see us running
down the stairs after a meeting ran late. (and we're ok that
sometimes you don't.) the words of encouragement you leave for us
on the sides of buildings and tucked in the pockets of a park
bench. that you're available 24 hours a day and you'll show up at
our door holding snacks. you're always game for anything. *anything.*
you make us feel like everything is possible.

we know you're not perfect. we see you pick yourself right
back up when someone knocks you down. your imperfections make you
beautiful, too.

no matter what happens, you show us that if we keep on going,
something is blossoming.

XO, *kate spade new york*

HOW WE FELT ABOUT OUR CITY, 28 YEARS IN. STILL DO.

4. FAVORITE FLOWER MARKET

3. OUR 1st OFFICE

5. FILMED A "missAdventure" HEre

5.

4.

3.

2.

1.

1. OUR 1st SHOP

2. fiLMeD OUR Summer 2021 camPAIgN HEre

81

# a good haircut

WHEN YOU MAKE AN APPOINTMENT with your favorite stylist, also make dinner plans with your favorite person or a whole group of them 'cause you're going out that night.

ALSO APPLIES TO wash day, a big chop, fresh box braids, a new color . . .

# painting a room

GATHER FOUR PEOPLE* who like each other and also like painting. do the prep work yourself before they arrive: take pictures off the wall, fill and sand any holes, cover your furniture. if you're using primer, do that now, too. have enough tools and brushes on hand for everyone. upon arrival, tape trimming and fixtures together and start painting. fuel the day with cool beverages (reserve alcohol for later), snacks, and music. a hearty lunch or dinner when the day is done is a nice thank-you; so is a prize for the person who splashed the least paint.

*the maximum number of people you want painting a room.

# date night!

(THE KIDS ARE SOMEWHERE ELSE.) do that thing you never can when the whole family is in tow: savor a long dinner someplace special or a scenic drive's distance away; skip out early from the office and meet each other for happy hour before a concert; do a spa night at home.

better yet, do something new and totally out of the ordinary, together. do a food tour. stay in and hire a private chef. rent a kayak. take a harbor cruise. get a lesson in graffiti art. trivia night!

# friday! *yay!*

PLAN A WEEKLY FRIDAY NIGHT glass of champagne with a friend, your partner, your favorite coworker, just to say "we did it"—or a rotation of people you'd love to see and catch up with.

if you can get the champagne served in a coupe just to make it feel even more special, even better. if you're doing all this at a bar, add a side of fries.

# small rituals.
# small occasions.

..........................................................................................

reach for that mug for that first coffee of the day.

order dinner in the night before leaving for a trip. no cooking, no cleanup.

have one cocktail at home before going out.

cook a new dinner recipe from the same cookbook until you've done them all.
(bonus points if that book is by julia child.)

bake chocolate chip cookies every time there's a full moon.

on the weekends, do your shopping at a farmer's market instead of the grocery store.

monday night bubble bath.

head to a favorite restaurant the moment you arrive somewhere,
be it your hometown or berlin.

say three things you're grateful for, every morning when you wake up.
(you'll have to dig deep some days.)

serve dessert for the main every saturday.

EACH NIGHT AT DINNER,
ASK EVERYONE AT THE TABLE FOR:

1 good thing

1 bad thing

1 nice thing they did

1 nice thing someone did for them

*celebrate the day.*

there's a first time for everything.

*medium*

# you're saying sorry

"be a little kinder than you have to."

—E. LOCHART

SO OFTEN, WE CAST AN APOLOGY as a symbol of failure. technically, it kind of is. looked at another way, it is also one of the most meaningful ways to reaffirm your commitment to someone. if both parties are willing, giving an apology and accepting one can make your bond stronger. like quality vintage, your relationship has survived wear and tear and is more valuable for it.

from planning it to giving it, approach your apology as a celebration of the resilience of human connection.

## plan it

the key to a great apology is to really own it. there is no "i'm sorry, but . . ." in this scenario. no asterisks, no takebacks. if there was, you'd be telling your recipient that you're not actually accepting responsibility.

when you are ready, make your message simple, direct, and sincere. don't rehash the past or bring in old wounds from bygone battles. it's not relevant and will sour your "mea culpa!" message. instead, focus on the now and the future.

## create a welcoming environment

these conversations are always best had in person. if that's not possible or you crumble in the face of confrontation, there are alternatives so you arrive in this space as your best self:

- text an audio message. it's the ease of a text, with a show of effort. it's like leaving a voicemail, without having to call. (you can even delete and rerecord!) jot down some key points. practice how you're going to say it. (tone of voice is very important here.) then, record and send this invitation to reconciliation and hope for the best.

- avoid sending a text message, no matter how much of a wordsmith you may be. your message could easily be misinterpreted. this occasion needs a personal touch. (we may be glued to our phones, but we are human.)

- on the timeless end of the spectrum, sending a handwritten card in the mail gives some space and time for both parties to decompress and reflect. plus, it gives you the chance to include a thoughtful gift. choose something based on shared knowledge between you two—their favorite tea or nostalgic candy bar.

if you're extending the olive branch after a mutual kerfuffle, tell that person they are the peanut butter to your jelly, the hocus to your pocus, the zig to your zag, the salt to your pepper—whatever pairing that they'll read as a term of endearment, and that will put you two on equal footing to start again.

all you can do is your part. it's the other person's choice to accept or not. whichever medium you choose for your invitation, "i'm sorry" opens the door. over time, actions welcome you in.

## receiving an apology

take the empathy you have for your friends' complexities and carry it with you on this ride. (people are weak and strange and fragile and funny and loveable, just like you. they make mistakes, just like you.) start by acknowledging that apologizing is never easy—it's ok to even say that. it may help diffuse some tension. do your best to reply with a "thank you," or "i appreciate you saying that." if you are caught off guard and aren't sure how ready you are to move forward, say that you need some time to gather your thoughts.

dear apt 707,

thank you for your patience during my "toddler phase." i'm sorry for all of my barking and crying; i haven't thought about how it affects the people around me. it will be over soon—i'm going to some behavior classes so that i pick up some manners.

as a peace offering, please enjoy these chocolate treats. i can't eat them myself, but i hear they're delicious.

woof,

cher,
the dog next door

THIS ALSO works for apologies we give on behalf of our dependents: naughty pets, crying babies, clueless houseguests, and faulty appliances. a handwritten note and homemade cookies, a bunch of flowers, or a potted plant can go a long way to demonstrate to a neighbor that you do indeed have empathy, that you do understand the permeability of apartment building walls, and that you do aspire to live in harmony.

# they're in town

CUE THE BACK-TO-BACK ACTIVITIES: when someone you love hanging out with comes to town, it's also a time for you to explore the city through the eyes of a visitor. things might get touristy. be sure to show them your favorite locals-only spots, too.

treat your visitor(s) to an attraction that only you as a knowledgeable local have intel on, plus a you'll-only-find-this-here food experience. add your spin to this general guide:

- *cultural excursion + brunch*
- *bike ride or hike + picnic*
- *lively dinner + a chill late-night jazz bar*
- *a scenic walk + a drink somewhere iconic*

you can also follow the rule of three[*] and tack on a visitor's choice. above all, take care of a friend in town. have plans that give you the flexibility to pivot, and if it's someone in your inner circle, introduce them to your local friends.

[*] *the rule of three is a writing principle that suggests that a trio of events or characters is more humorous, satisfying, or effective than any other number.*

# *you're going out!*
# how to glam up
# when you've got . . .

..........................................................................

**2 MINUTES:**

> add one or two of the following: a dramatic coat, big earrings, a fresh flower to your hair (plucked from a nearby vase), high heels, a single and well executed swipe of red lipstick, or anything else you can grab in eye's view that makes you feel more zhoozhy. alternatively, grab that dress you love that you always get compliments on.

**30 MINUTES:**

> steam. iron. defuzz.

**A FEW HOURS:**

> lay out your outfit. maybe you've tried a few things on and narrowed it down to two options, depending on your mood. go do something light and fun (mani-pedi, yoga, blowout, neck massage, eyelash extensions). then make a final selection.

**AN EXTRA MINUTE:**

> try on some stuff you haven't put on in a while. you might discover a new outfit or three.

# champagne basics

TO KNOW IT IS TO LOVE IT EVEN MORE.

## TO COUPE? . . .

- designed in the mid-1700s.
- shallow and wide.
- best used while stationary.
  high chance you'll splosh when walking.
- brings out champagne's flavor.
  ideal for older vintages.
- turns bubbly into still wine in 3 minutes flat.
- warms champagne faster.
  (warm champagne: bad.)
- fun vessels for martinis and manhattans.
- c'est chic.

## . . . OR TO FLUTE?

- designed in the early 1700s.
- tall and narrow.
- easy to hold. hard to spill.
- enhances champagne's aroma.
- better bubble flow.
- c'est classique.

### WHAT'S THAT CALLED?

the *muselet*. it keeps the cork
from popping off under the
pressure of the carbonated
contents. it comes from the
french word *museler*,
which means "to muzzle."
it comes off in six quick twists
of the wrist, every time.

# i drink it. what is it?

champagne ranges from brut nature to doux. it gets sweeter based on the amount of grape must (sugar) producers add to a bottle before corking it.

WHAT ABOUT CHAMPAGNE ROSÉ?

champagnes are an assemblage of wines, with chardonnay, pinot noir, and pinot meunier being the most common. rosé includes a smidge of red wine (usually pinot noir) to give it a light pink color. rosé can come in brut, sec, or doux varieties.

CHAMPAGNE IS A SPARKLING WINE,
BUT NOT ALL SPARKLING WINES ARE CHAMPAGNE.

"champagne" is reserved for grapes produced in the champagne region of france. the same traditional method of making champagne, though, is used in other regions of the country to make crèmant. there are twenty-three other sparkling wine regions in france besides champagne.

countries around the world have their own unique sparkling wines, including:

- ITALY: metodo classico, prosecco, and lambrusco
- SPAIN: cava
- SOUTH AFRICA: cape classique
- PORTUGAL: espumante
- GERMANY AND AUSTRALIA: sekt

THINGS YOU CAN DROP IN CHAMPAGNE

• bitters and honey • muddled berries • cassis • a scoop of sorbet • herb sprig • crème de violette • peach nectar • apple cider, sugar cube, and ground cinnamon

*this is the one you are drinking most often*

# champagne
## with a twist

### CHAMPAGNE MARGARITAS

combine ½ cup fresh lime juice, 1 cup tequila, ½ cup orange liqueur, and 3 cups (1 bottle) champagne in a large pitcher and stir. before pouring, lime and salt the rims of champagne glasses.

### CHAMPAGNE MARTINI

add 1 ½ oz vodka to a cocktail shaker filled with crushed ice. shake well. strain into a chilled martini glass. top with champagne. garnish with a strawberry.

### CHAMPAGNE COOLER

mix 1 ½ oz brandy and 1 oz triple sec in a wine glass. top with chilled champagne.

### CHAMPAGNE PIÑA COLADA

pour 1 ½ oz rum, ½ oz pineapple juice, and ½ oz coconut cream into an ice-filled shaker and shake until the container is frosty. pour in 3 oz of champagne and stir. strain into a chilled glass and top with pineapple slice.

TIP: quickly chill a warm bottle of champagne by wrapping it in a wet dish towel and popping it in a freezer for 30 minutes. but why not just keep a bottle of something fizzy at the ready in every fridge?

# BEYOND
# cheese
## and
# crackers

IT'S NEVER WISE TO SERVE BOOZE without a little something to soak it up, and while you could reach for a rote board of crowd-pleasing cheese and crackers, might we suggest something with a different panache that's just as easy to arrange?

## sabzi khordan

a plate of oven-warmed lavash or sangak*
fresh herbs on the stem: mint, basil, tarragon, fresh radishes, sliced lightly toasted walnuts, hunks of salty feta drizzled with olive oil

nestle together on a platter and encourage guests to make their own wraps.

*theatrically long sheets of thin flatbread sold at a persian market

## tinned fish

THE PACKAGING IS NOW SO GOOD, KEEP EXTRAS ON HAND FOR HOSTESS GIFTS
$20 anchovies that melt like butter
sardines
smoked octopus
crackers & crusty bread
sliced fresh or preserved morroccan lemon
flaky finishing salt

serve straight from the tin.

## corn chips and caviar

for the hostess who likes to play with high and low.

if beluga caviar is not in your budget,
look for more affordable
and shop for something domestic.

## cacahuates japonéses

good sub when bowls of peanuts feel stale

———

"japanese peanuts"
(mexico's favorite bar snack.
the crunchiest salty nuts.)

———

pair with ice-cold beer

## dates with
## salt and olive oil

a decadent middle eastern treasure.

drizzle fruity olive oil over sticky,
toffee-like dried dates.
sprinkle with flaky sea salt.

**THINGS THAT SHOULD NEVER BE SERVED AT PARTIES . . .**

• messy things. the exception is a crab feed • stuff that's mundane. you can have lasagne any night at home • steamed veg • things that are an acquired taste. they can really kill a mood.

# you got promoted

*movin' on up*

"she quietly expected great things to happen to her,
and no doubt that's one of the reasons why they did."

**—ZELDA FITZGERALD**

HEARING THE NEWS WAS FANTASTIC! now do something physically for yourself to mark the newness, like getting a body scrub to slough off the old stuff. it's a nice treat for a job (very well) done and deeply symbolic. a promotion is like a fresh start.

then, take your promoted self out to dinner, and get the nice wine. if you'd like a recommendation of where to go, we suggest somewhere any one of the following could occur: dessert is presented on a tray for your choosing, the tasting menu is an option, or you can enjoy oysters, fries, and champagne at the bar.

you could also buy yourself something to mark your success. something that you'll wear often, like a proper bag, a piece of jewelry, a classic watch. you'll be reminded of the occasion every time you look at it.

*let everything you wear tell a part of your life story. curate a closet full of trophies.*

most importantly, at some point in your celebration, send thank-you notes to all the people who helped you climb to this new rung on the job ladder.

# you all did it!

IN COLLEGE, a friend of ours marked the end of finals week by going to the semi-annual midnight breakfast: a feast of pancakes, bacon, eggs, and all kinds of fixings served after the very last exam had closed. it was the university's way of saying "congratulations!" to everyone involved. at 1 a.m., those hundreds of students, exhausted from back-to-back all-nighters but now well-nourished, then migrated to the campus lawn for the other tradition: a tribal scream on the count of three.

in a group setting, it's easy for individuals to think that they're not as good or good enough. only when everyone is in the thick of a big project, it becomes clear: it's ok, no one else knows what they're doing either. in the end, you collectively lift each other up and even each other out.

no matter how everyday the victory, find a way to bring everyone in for a hurrah before you all scatter to deal with whatever's next in your day or in your lives. start by just saying it. make purposeful eye contact. tell them "good job." reinforce how each team member sees their talents and contribution. then . . .

you could write *handwritten* everyone a ^note, but you could also . . .

. . . . . . . . . . . . . . . . . . . . . . . . . . . . . . . . . . . . . . . . . . . . . . . . . . . . . . . . . . . . . . . . .

**RING A GONG.** an actual gong. this may necessitate purchasing a small one and keeping it at your desk.

**ORGANIZE A VOLUNTEER SESSION** in the community une around.

**COMBINE ACHIEVEMENTS AND REFRESHMENTS** in a weekly "shout out" happy hour every friday afternoon.

**ORGANIZE A GROUP LESSON** around a skill everyone was talking about. like surfing, or korean cooking.

**IMMORTALIZE IT IN SWAG.** have everyone over for a meal or go out, give the gathering a catchy title, and send everyone home with a cotton tote bag emblazoned with the phrase to remember the celebration.

# congratulations, me

i, _____ , did it.
[YOUR NAME]

i, _____ , did not "get lucky." this was most definitely
[YOUR NAME]

not _____ .
["NO BIGGIE," "NOTHING, REALLY."]

my _____ was _____ .
[TASK]                              [AFFIRMATIVE ADJECTIVE]

i worked super _____ hard on it. i could not have
[ADVERB]

done it without the help of _____ , and i am really
[PERSON'S NAME]

proud of what we accomplished. i am _____ ,
[AFFIRMATIVE ADJECTIVE]

_____ , and _____ .
[AFFIRMATIVE ADJECTIVE]              [AFFIRMATIVE ADJECTIVE]

i am a _____ .
[ROYAL, FAVORITE SUPERHERO, OR OTHER HEROINE]

# congratulations, you

yessssssss! _____ , you did it!

[THEIR NAME]

i always knew you would _____ that _____ .

[AFFIRMATIVE VERB]              [NOUN]

it was so clearly _____ .

["NOT BY CHANCE," "NO BIG DEAL," "ALL YOU."]

i appreciate all of your _____

[SUPERLATIVE]

_____ . it did not go unnoticed.

[NOUN OR INTRANSITIVE VERB]

one thing i want you to remember: you are the _____

[SUPERLATIVE ADJECTIVE]

_____ of the _____ .

[SUPERLATIVE ADJECTIVE]              [NOUN]

trust me on that one. you're a _____

[AFFIRMATIVE ADJECTIVE]

_____ .

[EMPOWERING NOUN]

# they're planning a bris

## (a fun one.)

(SOME OCCASIONS are more eagerly anticipated than others. a bris, the jewish ceremony of circumcision, is characteristically anxiety-producing for everyone involved: the stereotype is of an exhausted new mother (a bris is performed the eighth day after birth) watching her newborn baby going under the knife in front of an audience. while they can't skirt the reality of why everyone is there, they can cause some distractions.)

# how hannah goldfield did things

for the bris of her son, otto, food critic for *the new yorker*, hannah goldfield broke from tradition. the circumcision was performed privately with the mohelet and immediate family, and she invited guests to share in the more poetic aspects of the ceremony afterward. (the mohelet will likely set the tone for the day. choose wisely and interview them well ahead.)

keeping with tradition, she and her mohelet incorporated singing at the start. normally, it would be a way to distract mom during the procedure, but the mohelet suggested they sing a lullaby. a moment of connection.

when my mom and aunt started singing 'tender shepherd,' i began weeping. i hadn't heard that song since i was a baby, and it all came flooding back. i looked around and saw my closest family and friends. i felt connected to my lineage, and it was momentous.

she did all this because at its heart, a bris is a naming ceremony.

as with every jewish gathering, food played a pivotal role in the larger group. "i tried to think about every shiva and 'break the fast' i'd ever attended and made a list of what we ate." that became the menu. then she served it all buffet-style, casual and abundant.

# i came for the circumcision,
# i stayed for the bagels and lox:

### HELP THE PARENTS OUT

- contact whoever is in charge of planning (usually a grandparent) and offer to pick up food, bring napkins, get freshly squeezed juice or a few bunches of flowers. preparation for a bris is usually harried, since the date is determined by the arrival of the baby. (not exactly something within grandma's control.)
- show up on time! a bris is not long, since the couple is tired.
- if the family has an older child, bring a small gift and pay them special attention. the arrival of a new sibling is a big transition. show them that they are still important.

### OFFER TO CREATE THE FOOD SPREAD

- if they don't keep kosher, still avoid shellfish and pork.
- a few different frittatas can be served at room temperature and will make great leftovers.
- generous bowls of seasonal fruit can double as table decor.
- keep the beverages simple: a self-serve bucket with wine and sparkling water if the event is in the evening. juice, coffee, and tea are a bonus if it's a morning affair.
- if the bris is happening after work during the week, remember that bagels and fixings are welcome any time of day (who doesn't love breakfast for dinner?).

AND if it's a girl, host a simchat bat. it's a bris without the circumcision. a rabbi is optional, and the event is most often held at home. host it anytime during the first year of the baby's life. draw on the general script of the bris, editing as needed.

## HOW TO

# *spruce the place up*

NO MATTER HOW MUCH TIME YOU HAVE BEFORE GUESTS ARRIVE.

...............................................................................................................

### IF YOU'VE GOT 30 MINUTES:

- tidy up common areas, fluff pillows, toss your clutter in a closet.
- wipe down sinks and countertops in the bathroom and kitchen.
- shove dishes in the dishwasher.
- take out trash.
- replenish guest bathroom towels, soap, toilet paper. draw shower curtain shut. light candle. dim lighting.

### IF YOU'VE GOT 1 HOUR, DO THE ABOVE PLUS:

- vacuum or sweep.
- clean toilet and bathtub. add a small speaker—piping music into the bathroom adds a swanky restaurant vibe.

### IF YOU'VE GOT 2 HOURS, DO THE ABOVE PLUS:

- clear and dust all surfaces.
- wipe down all mirrors.
- make beds.
- clean the kitchen.

# it's their birthday

FUNNY HOW THE CONCEPT OF BIRTHDAYS changes over time. early on, it's all about the day: a reason to have cake (childhood), go to a big party (teens), or crowd a bunch of friends into a tiny bar with drinks (our 20s).

as we know people longer, birthdays morph from a celebration of the day into a celebration of the person: their whole, wonderful, and sometimes-weird-but-that-just-makes-you-love-them-more selves.

cheer them on for the year ahead. tell them they're on the right path and you're right there with them on their adventure under the glow of $1 grocery store birthday candles on a really big cake. transform their birthday into a weeklong, even monthlong, celebration.

# a birthday in three parts

## on the day

HOST A THEMED DINNER. (THEME: THEM.)

we're taking our cues here from grace kelly, who, for her 40th birthday, threw a scorpio-themed soiree. the guests or the significant others of those guests were all scorpios. the dress code was for scorpio colors: red and black. portraits of famous scorpios like edgar allan poe and marie antoinette lined the ballroom where the dinner took place. (it should probably be noted that grace was a scorpio.)

throw your guest of honor a dinner based entirely on something they like a lot: wildflowers, anchovies, jazz . . . nothing is off-limits. make everything an homage to that thing, from the decorations to the food to what you all wear. if there are kids involved, make a game of the prep work. better still, ask them what the theme should be. (kids are perceptive like that.)

is it lemons? marigolds. limoncello. fennel and lemon risotto. lemon sorbet–filled lemons. everyone has to wear something yellow.

title the invitation "squeeze the day!" and mention how you're squeezing all of this person's most favorite things into a single meal.

## OR MAKE A DAY OF IT.

for a morning-till-night twist, put the birthday person in charge. they pick a food they adore. you shower them with it. this could, of course, be guacamole or meatballs, but it could just as well be double chocolate fudge donuts. they wake up to a mound of it. their lunch cooler gets filled with it. it's their dinner and dessert. the point of this, of course, is the spectacular willy wonka–ness of it all.

this will, no doubt, be very popular with children, who may want to start discussing it three months ahead of time.

## OR CARRY THE THEME THROUGH TILL MORNING.

"for my last birthday, the theme had to be pink champagne," says michele, our chief merchandising officer. "we had pink champagne and went out for dinner. the next day, we drank pink champagne and watched the academy awards in our pajamas. a birthday is an excuse to do all this fun stuff you just love, so why not do more of it?"

## later that week

## ORGANIZE A GROUP ACTIVITY THAT IS SECRETLY A PARTY WITH PRESENTS.

jenny, our CMO, loves prizes and birthdays so much that her best friend hosts a "jenny championship" for her in the park with friends, family, three-legged races, trivia, and, of course, an awards ceremony at the end.

## sometime that month

## GIVE AN UNEXPECTED GIFT.

show up with a present a week after their actual birthday, on, say, a random wednesday. right when they're least expecting it.

AND if it's your coworker, boss, or kid's schoolteacher, throw them a personalized party using things they say all the time. transform everything from ballpoint pens to balloons to cocktail napkins to walls (conversation banners) into a mirror of their personality.

# the gift whisperer

......................................................................

IT GOES WITHOUT SAYING, BUT the best things you can give the people you care deeply for are your time and your presence and your love. this might seem so obvious, but these things get lost among work deadlines, swim practice drop-offs, dinner plans, and bedtime routines.

of course, actual presents are also greatly appreciated, so here is our advice for giving the perfect tangible gift, every time.

- make note of those special days on your phone.

- keep a running list of things they casually mention wanting or liking, or their hobbies and interests. (later on, it shows you were listening.)

- give them something they'd buy themselves but would probably put off buying because it didn't feel "necessary."

- personalize your gift. it can be as simple as adding a monogram or as elaborate as having something custom-made. alternatively, curate a set of things. pair a beautiful pen from japan with a special journal.

- don't pick something only because you like it.

- don't wait until the last minute. when you see the perfect thing, buy it! even if the occasion is a few months away. let's say your friend ruins her favorite pair of shoes after stepping in dog poo but doesn't buy a new pair. go get them yourself, asap, and surprise her with them when the occasion arrives.

- size doesn't matter. the most impactful gift can be the tiniest bracelet charm if that tiny, shiny bauble symbolizes something meaningful.

PS: you can always bring a gift, even to the smallest of occasions, like getting coffee with an old friend.

*jenny walton,*

# what's the occasion

ANY OCCASION IS A GOOD EXCUSE TO CELEBRATE FOR NEW YORK–BASED ARTIST AND DESIGNER JENNY WALTON. PREFERABLY WITH FRIENDS, IDEALLY WITH CAKE, AND ALWAYS WITH A CAMPARI SPRITZ.

"SCOTT AND I WILL TRY AND USE ANY EXCUSE TO CELEBRATE. truly. he'll come home after walking around all day taking photographs and say, 'i got three shots!' and off we go to the italian restaurant next door for a campari spritz.

but as an adult, i think birthdays are the most fun thing. every year i make scott get me a big pink chocolate cake from magnolia bakery. we put it in the fridge, and i'll have it every day for breakfast and every night for dessert for a week until we can't even look at it anymore. it feels amazing and special when you go to a party and they indulge you, too. i'm not a fan of parties where you're planning the meal you're going to have afterward at the event. i went to a party last night and they had truffle ravioli and HUGE slices of chocolate cake.

i remember scott once gave me an album filled with photos he'd taken of me. putting it together was such an incredible gesture—a reminder of all the memories we have as a couple, and of outfits i need to bring back into rotation stat! i love clothes that have a sense of occasion to them. i go hunting for pieces i couldn't afford in school but can semi-afford now, and 1950s dresses: tulle! embroidery! sequins!"

# you could serve cake, *but* you could also serve

• SOMETHING CAKEY whoopie pies • lamingtons • mochi • donuts • midsommartårta • cornes de gazelle • brownies *plus* a choice of ice creams • malva pudding *and* frozen custard • basbousa • mandazi • ebelskivers • SOMETHING CREAMY banana splits • baked alaska • pavlova • sundaes • crème brûlée • trifle • kullfi • tiramisu • flan • banana pudding • ice cream sandwiches • tres leches cake • medovik • new york cheesecake • SOMETHING SWEET lemon squares • baklava • fruit cobbler • borma • cendol • alfajores • gulab jamun • yaksik • SOMETHING FLAKY deep dish pie • galette • profiteroles • cannoli • tart • SOMETHING VERY CHOCOLATY dark chocolate bars *and* fresh cherries • rigó jancsi • chocolate mousse • brigadeiros • chocolate caramel cream lollies • soufflé au chocolate • maðarica • fudge

6" round
serves 4–6

8" round
serves 8–10

10" round
serves 20–24

7" x 11"
serves 12–15

**IF YOU DO BRING OUT A CAKE:**

9" x 13"
serves 20–24

11" x 15"
serves 35–40

12" x 18"
serves 50–55

# they're meeting your people

IN ONE TELLING OF THE FAIRY TALE, you're announcing good news: you're in a relationship!

in the other (as adults, we now know fairy tales have bizarre twists), you're embarking on the most loaded series of social encounters in the trajectory of romantic life. feeling rattled by the potential extremities of emotions on all sides? totally natural, no matter how many times you've done this "first" before.

as you make your introductions, keep in mind that bringing together strangers under the pretext of "forever" can make people act in mysterious ways. come to each scene with a generous attitude and remember that, like any important occasion, it's on the organizer (in this case, you) to create a climate for success.

here's how to put everyone including yourself at ease so you have the space to actually *enjoy* this.

## your parents & closest friends

first impressions are important, but this is a long con. it takes time to build deep, lifelong relationships, and the ones between your partner and your parents and your closest friends are no exception. you hope that when your partner meets the other people who love you most, it plays out like a profound melding of the minds.

do a little planning, level-set those expectations, and you'll be able to embrace this moment as a celebration of expanding families, of new beginnings, of newfound love and all that good stuff.

PS: if things don't go perfectly, it's fine. you like your partner, and you're the one dating them. your parents and friends are not.

## IDENTIFY YOUR GOALS

jot them down so you can glance at them in case you hit speed bumps. no matter how mature you are, it'll be helpful.

## GIVE EVERYONE A CHEAT SHEET

prep everyone and your partner with talking points to fall back on should the conversation lose its lustre. spoon-feed them topics that you know they would find interesting about one another in advance, and avoid telling them what not to say. nobody wants to feel like they have failed a test before it even began. encourage questions! (within your sanctioned bounds.)

## SHARE A MEAL, BUT SKIP THE RESTAURANT

food is a great equalizer, but a restaurant can be . . . not so much, for a first meeting. you run the risk of amplifying any differences between those who love a white tablecloth and those who prefer a casual picnic. then there's always the question of who gets the check. (gulp.)

- consider something playful and light—a stroll through the farmers market for and a picnic in the park, a pasta dinner at your place, or ice cream and a walk in a beautiful setting.

- sign the group up for a cooking class. it's a dynamic alternative to a seated meal. choose a cuisine that is particular to your partner, or something unfamiliar and educational for everyone involved.

*try this recipe —>*

## DO SOMETHING TO KEEP IT MOVING

people tend to be at their best when they are challenging themselves physically or intellectually. choose an activity that subtly showcases something special about your partner. the goal is to create an inclusive environment where they can shine.

# roasted beet salad
## with apples, figs, and citrus

"food is a gateway to culture and a beautiful way to celebrate each other's food heritage. when we share a meal together, people ease into a comfort level where they can open up, share personal stories, and connect with one's heart. this recipe was inspired by a dish in jj johnson's cookbook *between harlem and heaven*, and shows the interplay of african, asian, and african-american influences, all of which i feel connected to as an asian american living in the beautiful, diverse city of NYC. i love the use of apples in this dish for the crunch, tang, and fall flavor."

—WEN-JAY YING

she's the founder of local roots nyc, a food pick-up and delivery service connecting local new yorkers to local farmers. celebrating people while sitting around a dinner table is one of her favorite things.

## SERVES 4

### SALAD:

- 2 lbs organic baby or medium beets
- 2 cups organic baby arugula or spinach
- 1 apple
- 3 tbsp olive oil
- ¼ cup citrus dressing
- kosher salt, cracked black pepper

### DRESSING:

- ¼ cup orange juice or yuzu juice
- 1 tbsp fresh lemon juice (omit if using yuzu)
- ½ tsp light brown sugar
- ⅛ tsp chopped thai basil
- 2 tsp dijon mustard
- ½ tsp kosher salt
- ¼ tsp freshly cracked pepper
- ¼ cup olive oil

• MAKE THE DRESSING: put all dressing ingredients except oil in a blender and blend until combined. slowly add oil, blending until emulsified. season with salt and pepper to taste.

• MAKE THE SALAD: preheat the oven to 425°F. trim beets, leaving 1 inch of stem, and coat lightly with oil. wrap tightly in aluminum foil and place on a baking sheet in the oven. roast until tender and easily pierced with a knife (around 1 hour). remove from oven. let cool for 10 minutes.

• peel beets with a small, sharp knife over parchment paper to prevent staining your cutting board. omit this step if you prefer to keep the beet skin on.

• while beets are still warm, cut each one in half, and then each half into 4–6 wedges. put these in a large mixing bowl.

• toss warm beets with half the dressing, 1 tsp salt, and ¼ tsp pepper. add arugula or spinach, and the remaining dressing. gently toss to combine. plate the salad and top with figs and apples. (don't add these till the end, otherwise the fruit will turn red from the beets.)

for example:

- sign up for a park cleanup, volunteer at a soup kitchen, or canvass for a local politician (if everyone is on the same page politically).
- visit a local museum. if the group's tastes are diametrically opposed, find a neutral cultural outing, something novel, or even campy, that you might not otherwise visit. neon museum, anyone?

## your kids

the most magical, but also terrifying, thing about young children is their unfiltered honesty: they'll point out the zit you've worked your magic to conceal without skipping a beat.

the first time your new partner spends quality time with your kids, plan something easy, lighthearted, and short. *low-key* is the operative word here.

- ice skating, roller skating
- fruit picking
- a picnic in the park (bring bread to feed the ducks. bonus if there is a farmer's market nearby for dessert.)
- go karts, bumper boats, miniature golf, or arcade games. if things go well, follow it up with pizza or ice cream.

as soon as you make plans, give your partner a heads up on some insider info: namely what your kids are into, so they can show up with a modest gift. if they need help picking something out, do it with them but not for them. you want them to choose something that says, "i get you but i'm definitely not trying to win you over with stuff": a book in their favorite series, a geode for the rock collector, something small and personal that will make them feel seen.

from there, tell your partner to play it cool. kids can smell fear and desperation, and most of them take a while to cozy up to a new person anyway, especially one is dating their parent.

possibly the worst (albeit totally well-meaning) advice you can give your beloved as they walk into these gatherings is "be yourself." we each have many versions of ourselves, from our best selves to our worst selves and everything in between.

more likely, you want them to show up as the best version of themselves, or the funniest, or the politest. you know your audiences best, so help your person out and advise them to be their _____ self instead.

# they got a new job

JUST WHEN THEY THOUGHT their last day would be without any fanfare, quiet, and calm . . . surprise them by showing up at their current (but, at this point, now old) job and taking them for lunch to celebrate their new one—better yet, a "late lunch" that lasts till 6 p.m. instead of asking them where they'd like to eat, tell them to guess where you're taking them to eat. then take them to their first guess.

WHEN YOU'RE

*celebrating their win*

YOU'RE ALSO

*nurturing your friendship*

..................................................................................................

REMEMBER THAT these are the people who tuck the tag in on your sweater, sit attentively on standby in case you need an extraction call from a bad date, answer "what time are we meeting?" to your "let's do something fabulous tonight" texts, hype up your awesomeness, explain why those jeans are not for you in the nicest way possible, and point out when when you have lipstick on your teeth.

so you could send your friends flowers, but you could also . . .

- send them a very extra text: OMG OMG OMG
- pause for a second to say: "that just happened." then actually pause. (or laugh, jump, hug or squeal.)
- surprise them with something mundane that they love. you showing up with a single morning glory muffin from their favorite bakery can feel like getting diamond earrings if that's the thing they're always jonesing for.
- lean into the ridiculous. if they love chocolate, fill a basket with chocolates and attach a balloon filled with chocolate. if they have been working nonstop, send them a spa-in-a-box filled with self-care goodies. (big box.)
- take them out for a drink.
- pay for dinner.
- send them a card in the mail. (the novelty of snail mail never wanes.)
- give them a mini break from adulting: you babysitting lets them have a celebratory night out with their significant other, or themselves.
- forget any concept of useful or appropriate and get whatever makes them happy.

however you celebrate a win, decide to be in that moment with your friend. be the reason they feel welcomed, seen, heard, valued, loved and supported.

Pozdravlyayu

Complimenti!

COmplimenti!

Tanti auguri

Glwckwunsch!

Congratulations.

# you're hosting an open house

YOU'VE GOT A *new apartment.*

YOU'VE MOVED IN *with your love.*

YOU BOUGHT *a house.*

YOU LAUNCHED *a new business.*

IT'S THE *holidays.*

IT'S YOUR *birthday.*

# you want a reason to see everyone. nothing fancy.

TAKE A PAGE from leo lerman and open your doors for a low-key, all-hours, come-and-go mingler.

leo was a new york city publishing legend and a fixture on the cultural scene for more than half a century as a book author, broadway stage manager, dance critic, and *vanity fair* editor.

all of these interests came together at his sunday salons. there, on any lazy evening, you might rub shoulders with max ernst and maria callas, or martha graham and marlene dietrich. but the who is not really the point. it's the why and how that we like.

lerman called these gatherings "sunday nights of mass affection." the tradition started in the 1940s with cheap wine, cheese boards, and chinese takeout in his modest basement apartment on lexington avenue and continued in much the same spirit later on at his palatial home in the osborne—right across from carnegie hall—until his death in 1994.

# who's coming?

cross-pollinate your friends, extended social circles, coworkers, and family who have similar interests or experiences. people are more engaged when they hear new information, so it will make for more lively conversations.

# dress up the place

a single color on all flourishes. scatter a variety of supermarket blooms in one shade in low vases everywhere: tucked atop the powder room sink, scattered about the buffet, enlivening side tables and fireplace mantles.

# food

listen to leo; food is not the focus. that being said, you want whatever you dish to be appealing. keep the snacks easygoing; delicious whether hot, cold, or room temperature, and manageable without loads of utensils.

# don't stress

- break prep work up over two days. set the table and bar the night before.
- ace one aspect of the event. wing it on everything else. incredible spread? economize the décor. one-for-the-ages activity? keep the drinks to beer and wine.
- avoid a rush of guests by slyly staggering the start/end times on the invitation.

and even if you run out of coasters and someone winds up perching on your kid's play table stool, as long as there are french fries in the freezer in case someone's kid doesn't like jammy eggs, and there's lively conversation, it will all turn out better than fine. if people stay longer than you planned with new numbers in their phones, now *that's* a sign of mass affection.

ALSO WORKS FOR college graduations, new year's day brunches, going-away drinks, pet adoptions, prom pre-parties for teens and parents, and everyone's-invited parties after small gathering occasions.

# a Menu

if all else fails, order takeout. because leo.

## pizza

bake a frozen store-bought pizza and just heap fresh herbs on top.

## jammy eggs

boil eggs to a texture halfway between hard and soft, halve and top with
a dollop of paprika mayo. garnish with sweet roasted peppers.

## salami slices

layer 2 lbs sliced salami and a handful of marcona almonds in shallow bowl.
top with grated lemon zest, black pepper, and lots of olive oil.

## avocado chip and dip

whip together 1 avocado, ¾ cup plain greek yogurt,
and 3 sautéed chopped scallions. serve with pita chips, crackers, or toasts.

## mini sweet pies

pick up some pies and cheesecake, a round cookie cutter, whipped cream, and
fresh berries. press cookie cutter into the pies repeatedly. carefully lift mini pies
out and place on serving plate. dollop whipped cream and sprinkle berries.

# crudités

there are lots of local odes to dips and dippers. here are some of them:

### THE UNVERSAL RECIPE:

- something refreshing • something starchy • something herby
- something citrusy • something pickled • sauce

......................................................................................

### NOW MAKE IT ITALIAN:

- young carrots, green beans, and spring onions, halved
- celery, cut into sticks • radishes, asparagus, and fennel, thinly sliced
- endive and little gem lettuces, leaves separated
- watercress, tough stems removed • lemons, quartered
- flaky sea salt • really good olive oil

......................................................................................

### NOW MAKE IT MEXICAN:

- fennel, sliced • radishes, halved
- kirby cucumbers and carrots, cut into sticks • green olives, rinsed
- salt • chili powder • key limes, halved

......................................................................................

### NOW MAKE IT NORTHERN CHINESE:

*in warm months:*
- radishes • cucumbers • yams • green onions
- cherry tomatoes, sliced • hoisin sauce

*in the other months:*
- corn on the cob • mini purple sweet potatoes • pumpkin
- edamame • steamed peanuts • a light dusting of sugar

......................................................................................

### NOW MAKE IT JAPANESE:

- carrots, radishes, and cucumbers, sliced • sesame dipping sauce with tahini, soy sauce, rice vinegar, grated ginger, and broth

# fun-for-all *drinks*

a DIY bar works on two levels. you don't have the pressure of refilling glasses, and guests have their drinks just as they like them. build this beverage situation away from your snacks area. spread out the fun.

- identify an easy-to-access surface like a kitchen island, dining room buffet, living room credenza, or a few levels of a bookshelf.

- fill with an assortment of liquors, bitters, seltzer, and tonic. add a cooler of canned beers, an iced bucket with wine, and mixers that are also satisfying on their own, like fruit juices, colas, ginger ale, and lemonade.

- write out 3 easy recipes on a small chalkboard or notecards.

ESSENTIALS:
- 1 cocktail shaker
- 1 generous bowl of lemons, limes, and mandarin oranges
- 2 paring knives
- 2 lidded buckets of ice
- 3 small dishes of olives, cocktail onions, and cherries (maraschino or luxardo)
- sprigs of fresh mint and basil
- loads of toothpicks
- cup of straws
- plenty of vessels (stemless glass tumblers work with everything)

# canapés
# for a
# crowd

# know your nibbles

**HORS D'OEUVRE:**
a small dish served
before a meal. some are cold,
some are hot.
also called an appetizer.

**AMUSE-BOUCHE:**
a single, bite-sized hors d'oeuvre.

**CANAPÉ:**
an hors d'oeuvre with a bread,
puff pastry, or cracker base
topped with something savory.

- fries in a cone
- dumplings
- shrimp cocktail
- mini cheese balls
- sliders
- bacon-wrapped dates
- mini frittatas
- scotch eggs
- blinis
- pigs in a blanket
- oysters
- crushed pea and mint toasts
- salmon and guacamole cones

it's not an hors d'oeuvre, amuse-bouche, or canapé,
but it's always a hit: an over-the-top charcuterie board.

# girls' trip

peru or paris?
a cabin upstate or a beach down south?
a flea market hop in the countryside
or a snow-filled ski excursion?

"i accept the great adventure of being me."
—SIMONE DE BEAUVOIR

# it starts the very moment you decide to go

after you've browsed the travel sites and sifted through posts you bookmarked on instagram, pick up a novel, film, or some music related to where you're going. the more detail, richness, and examples you bring to a concept—in this case, your destination—the more deeply embedded that concept becomes in your brain. (it's what scientists call brain plasticity.) the same is true about learning anything new, so fill your getaway with things you'll remember for a lifetime.

## the journey is half the fun

- if you're driving, rent a vintage car. preferably a convertible.
- if you're going by train, pack gourmet snacks and top-shelf booze (rules depending) and do happy hour in your sleeping car.
- if you're flying, use unused points to splurge on seats in business class.

## make the moments last

- give yourself an adventure budget for taxi cabs, trolley tours, spontaneous purchases, and long, long, long dinners.
- fill your itinerary with new things, from big to small. you'll come away enriched and recharged. if you were to engage in the same old things, your space-saving brain would condense those memories into old ones.
- feel some full-belly laughter. let a nice, big mug warm your hands. invite the sun to shine on your face.
- take a class: surfing, kintsugi, a cooking class with a local with ingredients bought together at the market.

- sign up for things the locals do: book readings, art gallery openings, concerts in the park.
- order and share every dessert on the menu.
- buy matching bracelets or necklaces and vow to wear them until they fall off.
- bring back something you can use at home: spices, bulbs for your garden, a candy dish for your coffee table.
- mail a postcard from your destination (the cheesier, the better) to each person before you head home. recap a highlight from the trip that meant something to you, or a tiny stolen moment between just you two, to cement the good memories.

## end on a high note

do the most special thing at the end of your getaway. this could be the best seats in the house at a local concert, like a zydeco band in new orleans or a norteño group in mexico city, or something as low-key as dinner at that tiny restaurant down the block that everyone in town recommends. spread out the fun. it gives you more to look forward to.

## turn this into a time-honored ritual

instead of being wistful about that "one night in barcelona," make a pact to do more trips—pinky promise, no take backs. base those future excursions on a specific time, place, or impetus to make it more official. bonus: this planning process also staves off last-day blues. going somewhere is a metaphor to keep moving forward.

## places to go, things to do and when to do it

- rotate hometowns and planning responsibilities; e.g., this time tour sarah's seattle, next time explore lili's shanghai.
- a destination celebration for a milestone birthday (30, 40, 50).
- anytime someone has a big life change, good or bad: moving in with a significant other or a breakup, starting or quitting a job, baby's on the way, kids have left the roost, an engagement . . .

> there's only one thing in life,
> and that's the
> continual renewal of inspiration.

—DIANA VREELAND

# moving party

FIRST, GET DOWN TO BUSINESS: organize for a couple of friends at a time to come over in 3-hour shifts to help you pack.* you provide the supplies and the sustenance. they provide the tunes. reserve the last half hour of each shift for snacks. no one gets tired or grumpy, there is bound to be some overlap as people come and go—those well-timed snacks cleverly double as a thank-you and a warm welcome—and it's a way to see a lot of people while balancing your big task at hand.

the day after the last box is stuffed, throw a big party in the empty space and invite everyone back for it. you're leaving rooms you've outgrown.

*to avoid an uh-oh, only you are allowed to pack the fragile stuff.

MOVIN' OUT MIX:

*"jardin d'hiver"* by karen ann
*"ces petis reins"* by stacey kent
*"sunny afternoon"* by the kinks
*"l'anamour"* by serge gainsbourg
*"cranes in the sky"* by solange
*"my baby just cares for me"* by nina simone
*"doo wop (that thing)"* by ms. lauryn hill

HOW TO MAKE

# a music mix

FOR ANY OCCASION.

..............................................................................

A GOOD PLAYLIST WILL LIFT SPIRITS FASTER THAN SHOTS OF TEQUILA.

**KEEP IN MIND THAT YOU'RE CREATING A MOOD.** choose your songs based on the general sound and tempo, rather than song titles or lyrics.

**MIX WILDLY DIFFERENT ARTISTS,** like lauryn hill rap and haim pop. genres don't matter. only transitions do: when making your playlist, select a bunch of songs you love. check that the last 10 seconds of each song flow smoothly into the first few beats of the next. reorder and edit down as needed.

**MIX NATIONALITIES:** french rap (mc solaar), american jazz (miles davis), and british alt pop (everything but the girl) play well together for date night.

**MIX UNEXPECTED TUNES WITH SONGS THAT PEOPLE KNOW.** even one or two you consider "too well known." you know those moments on a dance floor when everyone starts singing along? you want your playlist's version of that.

**MATCH THE TEMPO TO THE OCCASION,** but don't keep the same beat the whole time. events have waves of moods. if you're having people over for a birthday dinner, start with an upbeat vibe for cocktails, shift to lively instrumentals for dinner, and then mellow, downtempo songs for late-night conversation.

**NAME YOUR PLAYLIST** so you can revisit it and remember the event.

# it's the last night

*. . . before someone goes to college,*
*before everyone goes home,*
*before they move far, far away,*
*get the group together.*

IF THE DEPARTURE IS A MILESTONE (a family member is off to college, for instance) you might have a bigger and fancier to-do separately, at a proper venue or restaurant to mark the occasion or achievement.

this gathering is for the actual last night. a smaller, more intimate event involving quality one-on-one time. a celebration of the relationships among the group and as a group. between drinking, talking, eating, and reminiscing, why not play some games?

THE PLAYLIST: casually ask the celebrated for their favorite songs and surprise them with a soundtrack, or invite everyone to contribute their favorites to one.

THE TABLE: 
- you're going to be playing a game during dinner (and probably throughout the evening), so take inspiration from traditional game nights: cover tables with brown craft paper and secure with brightly colored tape.

- arrange markers in glasses and leave one at each place setting for random doodles and yearbook-style messages you can copy or cut up and put into an album to give as a keepsake of the night.

- in lieu of traditional place cards, write a memorable, funny, or endearing thing that person once did, that they will recognize. (if it's unfamiliar to anyone else, even better. tonight's the night they tell the tale!)

THE MENU: because farewell meals are all about the guest(s) of honor, plan to serve all of their favorites—and a toast is de rigueur. if you're toasting a few or all of you, assemble a menu by asking for one or two favorites from each guest.

- *no:* anything too fancy (champagne is the exception), complicated, or requiring special utensils.

- *yes:* flavorful comfort food. hopefully somewhere, on someone's list, are bite-sized grilled cheese sandwiches, mini pb&js with banana slices, salt and vinegar potato chips, and soft cake cookies.

PS: if your group has a good sense of humor, serve a big sheet cake at the end of the night with the words *"fine. go."* scrawled in bright-colored frosting.

there is one friend
in the life of each of us
who seems not
a separate person . . .
but an expansion,
an interpretation, of one's self,
the very meaning
of one's soul.

# knowing *me*, knowing *you*, knowing *us*.

A PARTY GAME THAT CELEBRATES WHY YOU MATTER TO ONE ANOTHER.

INSTRUCTIONS:

this can all change depending on the number of guests, but let's assume you're in a small group.

- choose someone to ask the questions.
- **round 1**: each person answers 5 questions about themselves from the about me list.
- **round 2**: each person chooses someone in the group to answer 5 questions about, from the about us list.
- extend the fun, amusement, and awe on some of these by following up their answer with a simple question: "*why?*"

ABOUT *you*:

- what makes you happy?
- what are three things you don't do?
- what do you consider your biggest achievement?
- what's one thing you continue to search for?
- what is your earliest memory?
- are you feeling optimistic?
- what advice would you give your younger self?
- what's the most vulnerable thing you've done for love? the silliest?
- if you knew you couldn't fail in your career, what would you be?
- what fictional character do you have a crush on?
- what will the title of your autobiography be?
- who will play you in the movie adaptation?
- if someone could walk a mile in your shoes, what would you hope they felt compassionate about toward you?

ABOUT *us*:

- how did you two meet?
- what did you think of them when you first met?
- choose four adjectives to describe them.
- what is their biggest strength?
- what's the most embarrassing thing you've done in front of them?
- what is the biggest disagreement you two have had?
- what is the biggest joy you two have shared?
- what can you always count on them for?
- what do you appreciate about them?
- what's something you still don't know about them?
- other than happiness, what's a wish or hope you have for them?
- what's something small they did for you that meant a lot?
- what was the first adventure you had together?
- what's the craziest thing you've gotten up to together?
- what's the best part of your relationship?

refill your glass.

large

it might seem strange to start
a story with an ending.
but all endings are also beginnings.
we just don't know it at the time.

—MITCH ALBOM

# they're single *again*

WEEKS BEFORE their sixth anniversary and impending divorce, karen elson and jack white sent out invitations to a select group of close friends and family, asking them to attend a party commemorating these two very important occasions. guests could expect "a positive swing bang hum dinger" with "dancing, photos, memories, and drinks with alcohol in them."

even if your friend doesn't feel like having a party themselves, it's time to celebrate everything you love about them the individual.

# party of two. (you and your friend.)

invite them over for takeout and a movie every night for an entire week. this checks a few boxes:

- ○ out of the house
- ○ no pressure
- ○ food and entertainment
- ○ friendly face

at first, getting over a breakup can involve emotions leaking out of eye sockets, monologues as therapy, and listening to songs that say the rest. that is good: it's a sign they were brave enough to let another human have an impact on them.

BE AROUND FOR WHATEVER BACKUP THEY NEED. be their safe space. be their garbage bin. be their warm hug. you can't fix your friends or their problems, and you can't protect them from pain. but you can be there when they're in the thick of it.

# pop the question. (no, not that one.)

when you're fairly certain they will be open to having some fun, ask if they want to take that trip to paris you two have always talked about, or sign up for that volunteer project helping to build homes in another part of the country or overseas for a couple weeks. dream big.

wherever you go and whatever you do (remember: you can do a spa day anytime. not now.), it'll remind them that they've always got love in their life, no matter what cupid has in store.

# and if they want a real party

do this.

INVITE EMPOWERING FRIENDS.

they will remind your friend how awesome and appreciated they are.

DECORATE WITH LOVE.

streamers in their favorite color, a life-size cardboard cutout of their celebrity crush, all the songs that get them singing and dancing.

GET A CAKE.

maybe get this written in icing: *hello world.*

SERVE THESE.

chicken and waffle sliders, chocolate-dipped kettle chips.

MIX A SIGNATURE COCKTAIL.

*me*-mosa: dry champagne or lemon sparkling water and orange juice. top with a garnish that is very them: a gummy candy, lavender, licorice . . .

A GROUP TOAST!

each person say two fun facts about the new singleton. it may help them see themselves the way you see them: able to do anything.

A PARTY GAME!

use the classic "never have i ever" setup, but make the experiences you've potentially never had things that might inspire their next life adventures.

DITCH SOMETHING SYMBOLIC.

create a moment for the guest of honor to get rid of something symbolic from the relationship that they are ready to let go of. could be their wedding dress, could be a love letter.

WATCH A MOVIE OR EVEN TWO.

(see list at right.)

OUR FAVORITE

*breakup*
*comebacks*
*on film*

THINGS TO WATCH COMING OUT
OF A POST-BREAKUP HAZE.

○ AN UNMARRIED WOMAN (1978)

jill clayburgh tries out single life
in '70s new york after her husband
unexpectedly leaves her for a
younger woman.

○ BIRDS OF PREY (2020)

after getting dumped by the joker,
harley quinn runs amok in gotham
city and forms an expanded circle
of girlfriends in the process.

○ THE HOLIDAY (2006)

a brit and a los angelean swap
homes post-breakup and bump into
something far better.

○ LEGALLY BLONDE (2003)

suddenly single for being a
"marilyn" instead of a "jackie,"
elle woods gets into harvard
law and graduates top of class.
thank you, next.

○ THELMA & LOUISE (1991)

romantic love may come and go,
but true friendship is forever.

○ WAITING TO EXHALE (1995)

replay the angela bassett
monologue. you know you want to.

# they've left the nest

SAY GOODBYE TO YOUR KIDS as they head off to summer camp, college, a weekend with their cousins. hug, kiss, tell them to have fun, be good, and all those things. then:

*a getaway. far away. a vacation without kids and dogs!*

*do more of what you love. do less of what you don't love.*

*conquer some clutter.*

*invite your friends over for a party. maybe it's dinner with another couple. maybe it's cocktails with everyone in your contact list.*

*plant a garden.*

*stay away from the grocery store. go out for meals. order in.*

*big glass of wine. maybe two.*

*do things you tell the kids not to do in the house. leave a glass on the coffee table. eat oily popcorn on the sofa. throw a shirt on the chair "just for a second."*

*refresh your nest. rearrange the furniture, or fully wallpaper the living room.*

*date night. every night.*

*take a day trip to see something artsy.*

*read the books that are sitting on your nightstand, or ones you'll pick up at your local bookstore.*

# you've moved into a new place home

"there is nothing like staying at home for real comfort."
—JANE AUSTEN

SEND A BOUQUET OF FLOWERS to your new address to greet you.

ON THE CARD:

*"to me, from me. you're so amazing. congratulations on your new place."*

poet gérard de nerval, who liked to take his pet lobster for walks in the palais-royal in paris, mused that "every flower is a soul blooming in nature." this, your new home, is where you're going to thrive.

## hints to give your friends

- come help out. ideally they'll bring you a gift: a set of plates in you favorite colors, a bottle of tequila. unpack a little. explore the new neighborhood together. enjoy local takeout with tequila on new dishes.

- bring you a few days' worth of home-cooked mains that freeze well or a couple bags of groceries. you'll be too busy unpacking to do it yourself those first few days.

- if you've moved far, you'd love a welcome package of coffee table books about your new location, be it mexico or upstate new york.

- new homeowner? a box of lottery ticket scratchies would be lovely.

# *another* ~~a~~ year together

IT COULD BE THE DAY you married, officially partnered, had your first date, your first kiss, or met for the very first time.

one of our friends does a special trip with her spouse every anniversary to somewhere on their dream-travel list. they bring back fun memories by making the foods and drinks they loved most the rest of the year. even if they don't make it every anniversary (2019 was cyprus, 2020 was tough), they have an ongoing list of places they'll go. her advice: make your list together.

an architect we know goes to the same italian restaurant in greenwich village for her anniversary every year. the bartenders know her and her spouse's order for drinks, starters, entrees, and yes, a special dessert.

if you and your significant other are party people, throw one and invite people who know you as a couple. if you're more intimate gatherers, host a small dinner or cocktail party. neither of these get-togethers need to be filled with anniversary-themed games, activities, conversation, or balloons.

GIVE AN

# anniversary gift

THEY NEVER SAW COMING.

...........................................................................

1ST ANNIVERSARY: *paper*
re-handwritten vows/ketubah, framed.

3RD ANNIVERSARY: *leather*
a wallet, for how fortunate you were to find each other.

5TH ANNIVERSARY: *wood*
pencils in an assortment of colors personalized with
iconic things each of you says, to keep on their desk.

6TH ANNIVERSARY: *candy*
a murano glass dish full of their favorites.

10TH ANNIVERSARY: *tin or aluminum*
champagne in a can.

16TH ANNIVERSARY: *coffee or tea*
have a custom tea blend made and name it
after your partner.

and never underestimate the power of midafternoon texts for no reason and
random compliments the rest of the year.

# you *finally* quit that job

QUITTING GETS A BAD RAP. as children we're told that it's something to not do. only as you get older does the penny drop and you realize that quitting isn't always about wimping out or a can't-be-bothered attitude.

when it comes to work, you owe it to yourself to find the best possible team and role where you can deliver your best you. the place where you are seen and understood, where you can grow on a daily basis, where you can be excited about the future. honoring your talent and experience is a form of celebrating yourself.

# if you're looking for something new

reframe your sights on the broader world that is available. "i had to leave college for a semester, and suddenly a friend said 'go for this day job as a stylist's assistant,'" remembers kristen, from our ideation studio.

"i didn't even know what a stylist was. i got the job, then someone left, someone else got promoted, and suddenly i had the associate stylist's job. none of that would have happened if i hadn't left. on a side note, when i went back to school three years later, i had made enough money during my break to pay tuition."

# if you're going somewhere new

save up funds before you leave to give yourself a month off. book a long trip somewhere on your bucket list. do a bunch of things on your bucket list. the time you take in between jobs is the only time you're ever *truly* out of office.

AND IF IT'S YOUR COWORKER take the celebration out of the workplace. you'll be able to curate a guest list of their favorite people and have actual conversations. not just work chat.

if your group goodbye has to happen on-site, a thoughtful sentiment goes a long way. when the card gets passed around, be specific about what made your almost-ex colleague such a mensch, and tell them exactly which of their talents their next employer will be lucky to have on deck.

IF IT'S YOUR FRIEND get them a gift that will help them create a new chapter for themselves—and be reminded of your support every time they use it: a leather portfolio, headphones for blocking out the noise during an all-day café work session, or even a skills class to boost their job-seeker confidence.

# you found your phone after you thought you lost it

*phew.*

NOW SCAN FOR ANY major texts, emails, or alerts (most likely there are none) then celebrate by putting it away. (in a safe space, please!) extending this experience of not hyper-managing your life or wasting time looking for things to engage with on can be very rewarding.

66

surround yourself with people
whose eyes light up
when they see you coming.

99

—ANDRE DÉ SHIELDS

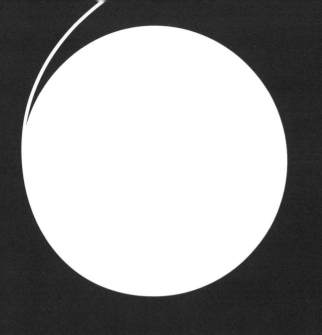

who
wants a
drink

# cocktail, s'il vous plaît

- aperol spritz, any time of year
- manhattan with extra cherries
- bloody mary
- casablanca
- cosmopolitan
- daiquiri
- diamond fizz
- french 75
- frisco
- kir royale
- lemon drop
- margarita with mezcal
- martinis, specialty martinis, and
  extra-dirty martinis
- mojito
- moscow mule
- pimm's classic
- pink champagne
- whiskey sour
- woo woo

# how (almost) all cocktails work:

sweet    +    bitter/sour    +    base spirit

# how to make a cosmopolitan that doesn't taste like 2002

but does taste like a popular version from 1934.

in a shaker, muddle 6 raspberries. add 2 oz gin, ½ oz orange liqueur, and ½ oz lemon juice and shake over ice. strain into a chilled cocktail glass.

# all the spirit, none of the booze

### CUCUMBER GIMLET
combine 1 ½ oz club soda, 4–5 slices of muddled cucumber, 1 oz fresh lime juice, and 1 oz simple syrup and shake with ice. pour and top with cucumber ribbon.

### SHIRLEY GINGER
stir 1 cup ginger beer, ¼ cup club soda, 1 tbsp fresh lime juice, and 1 tbsp grenadine. pour into a tall glass with ice. top with a maraschino cherry or twist of lime.

### ROSEMARY BLUEBERRY SMOOSH
muddle 8 blueberries, 1 stripped rosemary sprig, and 1 oz honey in a cocktail shaker. add 1 oz fresh lemon juice, shake. strain into a tall glass with ice. top with sparkling water and stir.

### BERRY BEE'S KNEES
shake 1 oz still water, ½ oz lemon juice, and ½ oz honey. strain into a tall glass with two raspberries. garnish with a third raspberry.

# DRINKS TO
# START AND END THE NIGHT

this is just a mojito and a ginger lime spritz. you can make pretty much anything celebratory if you give it a fun new name.

### HELLOJITO

muddle 3 mint leaves with ½ oz simple syrup in a shaker. add 2 oz rum, ¾ oz fresh lime juice. shake. strain into a highball glass filled with fresh ice.

### HASTA LA FIZZA

muddle a 2-inch piece of peeled ginger in a cocktail shaker. add 2 oz fresh lime juice and 2 oz simple syrup. top with prosecco and club soda. stir. top wih a sprig of mint.

### GARNISHES THAT MAKE ANY DRINK CELEBRATORY*
- paper umbrella • edible flower • cotton candy • citrus peel twist
- salt rim • cucumber ribbon • striped straw • sweet or sour cherry

*even water

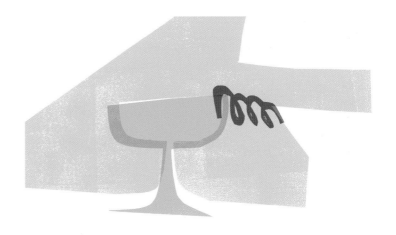

### ANOTHER WAY TO KEEP YOUR GLASS HALF-FULL WHEN IT'S HALF-EMPTY

when you have a really good day,
make dinner a little celebratory.
if you don't have a good day,
do something nice for yourself
to say it'll blow over.

# out-toast them all

**(NOT THAT IT'S A COMPETITION OR ANYTHING.)**

..................................................................................................

- if you've been asked to give a toast, ask the person what they're hoping for. short and funny? short and sweet? short and tear-jerking?

- then ask yourself: why you? the answer to that could spark ideas about what you'll say.

- your toast should tell your audience something they don't already know. start with a particular time, memory, or character trait in your opening line to focus it.

- at the event, wait your turn. in formal settings, the host should always be the first to speak.

- introduce yourself. it makes you more interesting to the group if they know how you're connected to the guest of honor.

- tell your quick, relevant story. use notes. at least have notes. just in case.

- keep it tasteful. positive vibes.

- if you get emotional, pause for a moment to pull yourself together. then, keep going.

- nail the close. after the beginning, the other most memorable part of a toast is the end.

# "

you are saturday to me.
and my friday night.

# "

**—DEBORAH ORR**

to her lifelong friend suzanne moore

here's to love,
the only fire against which
there is no insurance.

—A BOOK OF TOASTS, 1906

# ichi-go ichi-e.

in japanese, this roughly translates to "for this time only."
because even if the same people met again in the same place,
things would be different.

# how to deal
# with the morning after
## *like a grown-up*

stock your fridge
ahead of time with foodstuffs
that will make you feel better.

if you wake up at 7:30 a.m. after
a big night out and feel fine,
that feeling is false. go back to sleep.

drink water. a lot of water.

# *favorite breakfasts*

..................................................................................

- a slice of chocolate babka. really big. huge.

- diner eggs and french fries

- pickled plum and mentaiko onigiri (japanese rice ball)

- a hearty bagel and canned soda

- pancakes

- peanut butter on toast and coffee

- a giant bowl of kids' cereal with milk

- avocado toast and an egg

- chocolate milk

- a greasy breakfast and a fountain soda

- huevos rancheros

- clam-flavored miso soup

- juiced cucumber, kale, apple, ginger, lime. shot of vodka optional.

- bacon, egg, and cheese. please.

# part

WHEN ARTIST, DESIGNER, AND ENTREPRENEUR PAYTON COSELL TURNER CELEBRATES, SHE TAKES HER
GUESTS SOMEWHERE WONDERFUL—WHETHER BACK IN TIME TO A CHILDHOOD MEMORY OR ACROSS
THE OCEAN TO A COZY EUROPEAN BISTRO.

# y like Payton

"WHEN MY MOTHER WAS A YOUNGSTER, she loved reading *the haunted attic,* one of margaret sutton's judy bolton mysteries. in the sixth grade, she threw a halloween party inspired by the book, and years later, she passed on her love of the book to me and threw my friends and i a similar party when i was in the fourth grade.

a few years ago, i leveled up this tradition and transformed my home into a sinister cathedral of sorts, complete with a graveyard out back, a bonfire, tarot readings upstairs, a dj, murals to set the scene, and unconsecrated communion wafers for guests to snack on.

i love the idea of creating events that honor various versions of myself with a little added camp, but i'm big on everyday celebrations, like going all in on preparing a pasta dinner while blasting italian music and setting the table, or inviting my neighbor over to see my peonies which have just bloomed for the season.

it's easy and inexpensive to create an event that makes people feel like they're a part of something special. if you have to focus on two things, make it lighting and sound. swapping in a colorful lightbulb or two and creating a great playlist does wonders."

# best hostess gift

..........................................................................................

**SOMEONE WHO SHOWS UP** with something more fun than the BYO bottle of chardonnay—because the best way to get invited back is to bring a little something special. some tried-and-true favorites:

- a classic board game

- a pint of ice cream from a nearby creamery

- a bottle of pink champagne

- a nice bottle of their favorite spirit

- a copy of one of these:
  - > elsa schiaparelli's *shocking life*
  - > ruth reichl's *comfort me with apples*
  - > jen sincero's *you are a badass*

- a pretty tray for pretty little tidbits

- a basket of freshly baked breads and treats from the local bakery

- flowers in a vase, sent the morning of

# cak

ANASTASIA CLEVERLY DREAMS UP OUR DIGITAL CONTENT, AND SHE GIVES SONGS (AND CAKES) A PERSONAL TWIST, TOO. SHE SANG "PAPA MIA" FOR HER DAD'S BIRTHDAY, A TWIST ON THE MORE WELL-KNOWN "MAMMA MIA." IN TURN, HER DAD CHANGED AND SANG ANOTHER ABBA SONG TO CONTINUE THE JOKE AT ANASTASIA'S WEDDING. IN A NOD TO HER NEW HUSBAND, NAMED PETER, DAD SANG "AND PETER TAKES IT ALL," AFTER "THE WINNER TAKES IT ALL."

# e *a la anastasia*

# the cake situation

cream

Berries

"*years ago a school friend and I*

WANTED TO MAKE A

*special layer cake*

FOR ANOTHER FRIEND'S BIRTHDAY!

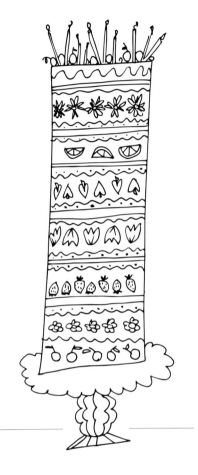

WE NEVER MADE ONE BEFORE,
BUT WE WERE DETERMINED.

*we baked for five hours straight.*

THE FILLING TURNED OUT GREAT,

*the cake, not as much.*

WE WENT TO THE STORE

AND BOUGHT

FOUR PREMADE LAYER CAKES . . .

*We took them apart*

AND ASSEMBLED OUR OWN

CREAM + BERRIES BETWEEN EACH LAYER.

*We absolutely said
We made it ourselves.*

THE FRIEND STILL DOESN'T KNOW TO THIS DAY."

# they're graduating

WHETHER THEY'RE LEAVING high school, college, or postgrad, this is a celebration of one chapter ending and another one beginning. for such an occasion, our favorite combination is also twofold: a useful gift and a meaningful and very extra woop! of a gesture.

# thoughtful gifts

- a chic wallet stuffed with cash and your handwritten note
- a sleep mask that also blocks out noise. roommates are still likely part of their near future.
- a yearlong subscription to their favorite food delivery service
- a snazzy watch
- sophisticated headphones
- a pair of commuting essentials: a work tote that holds a laptop. a thermo-flask for coffee.
- a weekender bag for trips home (or anywhere else)
- a cookbook they'll actually use
- a monogrammed planner or leather notebook

# fun ways to say hooray

ORGANIZE A DRIVE-BY PARTY:

get everyone who has supported them (especially in their education goals) together, make a bunch of congratulatory signs, and arrange a time for them to drive by their house as a surprise cheer. arrange a casual reason for that person to be on the porch or the front lawn when the first car comes down the block. (someone's puppy usually works.)

INVITE EVERYONE OVER:

cook all their favorite foods from their favorite meal of the day. have everyone share one way they've seen the newlygrad excel during the course of their study, plus one wish they have for them for their future.

CREATE A "TAKE A CHANCE" ALBUM:

adhere stationery envelopes (opening side out) to the pages of an album side-to-side, top-to-bottom. give family, friends, and mentors each a matching correspondence card to write one piece of advice or wish they have for the graduate. tuck their cards into the envelopes. it can be opened and read in the days, weeks, and months after graduation.

# they got engaged!

SET THE TONE FOR THE FUTURE NUPTUALS: bring to life a version of the traditional wedding recipe that is personal to them. let's say it's . . .

something gold, something new, something pearly, something blue.

*date:* technically, the books say a saturday or sunday two to four months after proposal. but just do it whenever people are ready.

*time:* early afternoon

*location:* your home

TABLE:
- set clear plates atop white paper doilies with guests' names written in beautiful black ink.
- a mix of ornate, modern, and vintage teacups. (flea markets are good resources. so are the cupboards of invited guests.)
- wineglasses as water glasses
- cake stands of varying sizes to hold colored pastries
- gold flatware

DECOR:
- a profusion of fragrant peonies in a vase, or a mix of bright pink and white roses, bunched low and tight
- antique vanity trays as serving piece

THE PLAYLIST:
*kiss me, kiss me, kiss me* by the cure
*beggars banquet* by the rolling stones
*among my swan* by mazzy star
*gymnopedie* by erik satie
"your love is king" by sade
"la vie en rose" by grace jones
"my cherie amour" by stevie wonder
"c'est si bon" by dean martin
"addicted to love" by florence + the machine
"it's always you" by chet baker

when sending the invite, create and share the link to a group spotify playlist and invite everyone to add their favorite love songs to it for the event. you can send the soundtrack to the guest of honor after the party's over.

MENU:
- conversation heart sugar cookies (rebrand them as "contented heart cookies" for this occasion) iced with a mix of sweet and saucy love sayings ("luvr" "cutie" "je t'aime" "darling" "sweetie" "kisses")
- raspberry mousse in short, delicate glasses, served with vintage teaspoons
- blackberry lemon polenta cake
- sweet and savory tarts
- petit fours and madeleines
- mini cherry cheesecakes
- a few unexpected flavor blends of tea. (skip english breakfast. grab the rose cacao.)
- champagne with muddled berries
- assorted tea sandwiches: buttered radish rose, beet and goat cheese, cucumber and cream cheese
- a bountiful tray of crudité popped with veg in various shades of pinks and reds, including radishes, watermelon radishes, and red bell peppers alongside cauliflower, snap peas, and celery with taramosalata (a pretty pink greek dip made with fish roe and potatoes as a base)

IF you're the one attending the party and are not expected to bring a gift but want to, give it to the guest of honor privately to open later, or mail it.

# radish rose tea sandwiches

**MAKES 4**

- 3 red radishes
- 4 slices white bread
- 1 tbsp butter, softened
- salt

- slice the radishes on the thinnest setting of a mandoline slicer to create 28 radish slices. blot to dry using paper towels.

- cut two circles out of each slice of bread (avoid crust) using a round cookie cutter.

- to assemble the sandwich base, butter a bread circle, top with a radish slice, spread butter on the top of the radish, then bread, then butter again. generously butter the top of the sandwich where the radish rose will be placed.

- to create the radish roses, take 6 radish slices and cut in half for 12 half-circles. fan out 4 radish half-circles slightly so the pieces stagger side by side. take one end, loosely roll it and place on top in the center of the butter, flat side down. with 4 more radish half-circles, fan slightly and place around one side of the center of the radish rose. use the last 4 half-circles, fan slightly, and place it around the other side.

# please
*come*

thank
you

# *choosing your*
# invitation style

WHETHER YOU TEXT all your friends and family to show up at city hall tomorrow at 3:30 p.m. sharp because (surprise!) you're getting married, you send a chic SMS invite for the school fundraiser so no one can say they didn't get it, or you send out engraved invitations for a random sunday supper, that's entirely up to you.

we're just here to tell you that you've got options to match your mood.

*pop, fizz clink!*

they're

*finally doing it!*

getting ~~married~~

*let's raise a glass*

~~please join us~~

in ~~celebrating~~

*to*

their engagement

saturday, 23rd may

at izzie's ~~home~~

4:00 p.m. ~~–6:00 p.m.~~

*till i shut the circuit breakers off*

# whatever your medium, use lively words.

include the party specifics plus something that will make the recipients smile, even on the fanciest invitation.

### FEELING FORMAL?

[HOST] requests the pleasure of your company at a dinner party in honor of her [REASON YOU'RE CELEBRATING] at [LOCATION] [DATE] [TIME] [RSVP]. dress: up!

### FEELING WITTY?

let's get fizzy! come for canapés, confetti, and cocktails in celebration of [OCCASION] [LOCATION] [DATE] [TIME] [RSVP]. festive frockery encouraged.

### FEELING PLAYFUL?

look who [REASON YOU'RE CELEBRATING]! join the party [DATE] from [TIME] at [LOCATION]. drinks and dancing till late! bring bubbly!

### FEELING LIVELY?

it's time to party . . . i'm [REASON YOU'RE CELEBRATING]! join a bunch of us on [DATE] for cocktails at [TIME]–ish followed by dinner at [TIME]–ish. location to be revealed. [RSVP]

after sending or pressing send, expect three-quarters of the people you invited to attend. unless you're getting married somewhere everyone wants to visit; then they may all come, and stay for the honeymoon, too.

# making your guest list

the best parties have some exclusivity—as in, a very clear reason why each person would or wouldn't be there. because of this, people are automatically interesting or of interest to other people there. it's how "who are you?" leads to "how do you know the host?" leads to "can i get you a drink?" being able to create that feeling is magic as a host, no matter what the occasion.

# saying thank you

a handwritten note is timeless, always appropriate, and, with so many ways to say thank you now, a delight to find in the mail stack.

that being said, it's perfectly acceptable to express your thanks in the same way you were invited—if you were invited to dinner on the spur of the moment, feel free to call the day after. we also like the audio message—it's as easy as a text message, but with heart.

if you get invited for dinner and you're in charge of dessert, swing by your favorite grocer or bakery, pick up a cake, and have them scribble a random (to them, at least) message across the top in frosting: "thank you for dinner!" dessert (check). thank you (check).

word to the wise: it's never too late to say thank you, though you should do it as soon as possible. if you're the holly golightly of occasions, the five-parties-a-week-every-week type, do yourself a favor and keep a stack of all-occasion notecards and stamped envelopes in your drawer.

AN EVENTFUL THANK-YOU EQUATION:

- give a genuine compliment to the host about the event.
- share one thing that it, or something that happened during it, has inspired you to do.
- end with a warm wish ("it was wonderful spending time with you").

A GIFTED THANK-YOU EQUATION:

- give a genuine compliment to the gift-giver about their gift and how it made you feel.
- share a detail about how you're going to use or display the gift.
- end with a warm wish and compliment about your relationship ("it was so sweet of you to think of me, and i'm so glad we're friends").

# *cheers!*
# to the late bloomers

WHETHER THEY GOT THEIR driver's license at 37 or graduated college at 65, learning to do anything later than they "should have" is a big deal. them sharing with you that they did it (which, conversely, requires admitting that they hadn't done it) is an even bigger one.

so make a big deal of this moment. throw them a proper graduation party, just like the 20-somethings get. take a road trip (they get the wheel, you get the radio dial). whatever lets them bask in the spotlight of their win, do that. their achievement shines a light on the infinite possibilities of who we all are.

nothing is impossible.
the word itself
says 'i'm possible.'

—AUDREY HEPBURN

it's about time.

large

# it's
# mother's
# day

SOMETHING WE LOVE ABOUT MOTHER'S DAY is the idea that moms are all around. adoptive moms, biological moms, mentors, grandmoms, chosen moms . . . there are so many ways to be a mom, and each of them deserves our gratitude and accolades. mom is everything, no matter how she's yours.

## "all i want is to sit poolside with a cocktail in my hand and my husband on standby keeping my glass full."

on this single day of the year that we heap our thank-yous on, an everyday act of kindness could be the very thing she wants most: a colleague of ours wanted a day by the pool and lounger-side service. whatever your mom's version of a poolside oasis is, create that for her.

# loosely translated, here's a formula:

*meaningful location* **+** *something indulgent* **+** *your time*

......................... **YOU MIGHT:** .........................

| | | | | |
|---|---|---|---|---|
| have her over to yours | + | a piece of jewelry inscribed with "i am beside you" | + | a slideshow of her greatest mom moments |
| virtual lunch date | + | her favorite dishes delivered from her favorite restaurant | + | you dressing up for your video call |
| wherever she chooses | + | whatever she chooses | + | no one asking her to do or solve anything |
| her home | + | you and the kids cooking dinner in the kitchen | + | remind her what you love most about her in a toast |
| theater, movie, or concert | + | tickets and dinner for you both, your treat | + | shop together for something new to wear |
| that class that she's been wanting to take | + | ice cream afterward | + | you doing both of these things with her |
| a spa day | + | audio messages from the kids to play while spa-ing | + | be her chauffeur |

# your gift to mom could also manifest as . . .

"some of the greatest words of wisdom, guidance, and encouragement i have received have come from 'mentees' of mine. when i became co-executive director of the lower eastside girls club at age 29, shandra, a girls club alumni, made sure to tell me that, especially as a black woman, i deserve to be celebrated and to make space to invite joy and praise as i took on this new role; that i don't have to keep grinding; that i should take pause to relish this new accomplishment and be proud. i didn't realize how much i needed to hear that, and i will never ever forget the gift of that sage advice." —ebonie simpson.

### GETTING A WHOLE BUNCH OF MOMS TOGETHER.

"as soon as i had a space to entertain, i started hosting a mother's day brunch for friends and family. i would make it as special as i could: little plants with their names on it at the table and any little gift i thought a woman would appreciate. i began calling it mother's day open house. after i had my own children, i continued to host it because it brought me so much joy to honor the moms that were so important to me. today my own children—jack is 18, ben is 15—now celebrate me with all the things i love, and we host the brunch together."
—jennifer. she's the president of our shoe division and once filled her house with disco ball lights for jack to wake up to on his 18th birthday.

"the things that have meant the most to me as a mother were small but genuine: small cards and poems from my kids telling me how much they love me. the things they wrote were funny and sometimes accidentally odd, but always true and from the bottom of their hearts.

i also remember when my mom called to wish me happy mother's day for the very first time. i wasn't expecting it; i always thought kids called their moms, not the other way around. but it was my turn to be a mother, and her celebrating this and supporting me in my new role felt incredibly empowering." —loris, our director of special projects. she would love an awkward poem over heart-shaped chocolates any mother's day.

## CARRYING ON A FAMILY TRADITION.

"i vividly remember the annual ceremony that was mother's day breakfast in bed for my mom when i was a young child. i can recall the faded painted wood tray i would use to carry it up the stairs, taking each step so carefully as to not spill even one drop of hot coffee, the smell of scrambled eggs with buttered rye toast (her favorite) greeting me as i climbed. as i got older, i shouldered more of the actual cooking and preparation and remembered how proud i felt to actually be in a position to do something for my mom, instead of the other way around.

i had all of those feelings again and more when my six- and three-year-old sons brought me breakfast in bed and homemade cards this past mother's day. as i watched my boys feverishly walk back and forth to the kitchen excitedly saying 'we have so much to do' and propping up my pillow and bringing me coffee followed by a tray with eggs and toast, i thought to myself, this is motherhood." —charlotte, our vice president of americas wholesale, travel retail, and global licensing.

"my family lays out some fresh bagels and lox, champagne, and some fruit in our kitchen for brunch that i can enjoy in my comfy pajamas. my beau keeps my son occupied for the day so i can go for a long walk, watch tv, work in my garden, read a book on my porch, and just chill. for dinner, we order my favorite meal from my favorite restaurant. beyond that, all i want for mother's day are big, long hugs from my family, a thoughtful card, and some flowers. it's glorious, never gets old, and makes me so happy." — jackee, our senior director of global licensing. she remembers that her mom used to want to spend the day at home relaxing with her kids every mother's day, too.

AND if it's father's day, we love the combination of a useful gift that's a little more extra than he would buy for himself, along with a handwritten note and quality together time with you. this is the man who brought home the bacon you ate, cheered you on at game time, and would sometimes open "the bank of dad" for 24/7 service. he drove you places and then taught you to do it yourself. he also taught you to be punctual. (you never listened.)

# it's your

[INSERT AFFINITY GROUP HERE*]

# reunion

*several days.
plenty of personalities.
lots of memories.
a tinge of nerves.*

*extended family, former coworkers, summer camp buddies, high school athletics, teammates,
college clubs, staffs, or casts (e.g., debate, glee, newspaper, coffee shop, dive bar, drama)

# those tiny details

AS YOU'RE ~~LOSING YOUR MARBLES~~ working through the foundational details like location, food, travel, and accommodation, these will make a get-together of longtime sidekicks one for the history books:

- give each attendee an assigned role in the reunion that suits their proclivities; e.g., accountant, activity director, concierge.

- ensure the price point doesn't leave anyone out; t&e budgets may vary wildly within even a tight group.

- align with fellow reunion-goers on a plus-one policy: yea or nay.

- orchestrate an itinerary that spans a spectrum of moods and moments, from expressive to introspective, one-on-one to all hands on deck, looking back to looking forward.

- get everyone to pitch in for a professional photographer for two hours; you're already dressed up, you want to remember this when you're old, no one wants to miss out on being in all the photos, and if it's not on instagram, did it happen?

- to accommodate anyone who can't join in person, build a group video call into the formal itinerary.

- account for the early risers and night owls who will want to fill in the gaps of a multiday gathering with some alone or small group time: provide a one-sheeter of nearby cafés, cocktail lounges, bookstores, walking trails, and the like.

- make some swag: sweatshirts, tote bags, or writing pens printed with an iconic group-ism, or decks of cards printed with funny pics from deep within everyone's hard drives.

FOR A SMALLER AFFAIR, consider leveraging an existing event that draws a crowd, and orchestrate a more intimate component for the ones you want to see in a smaller group.

manage expectations and anxieties with interactive tech tools made just for meetups like these. look for apps and digital services for:

- busy calendar alignment
- one-stop registration
- settling the bill
- co-creating moodboards
- sending digital invitations
- booking group lodging reservations
- archiving everybody's milestones since the last time you convened

the overarching goal of these tools is that no one gets trapped in a "reply all" email thread. no one.

AND if it's been a minute since you've all hung out, go into the day/night/week with the plan to reunite as strangers; people are constantly evolving, and it's best to approach these relationships anew with fresh eyes and open hearts.

"

i host sleepovers
with my girlfriends. we're grown
women. we'll watch a few
episodes of *golden girls* every time.
we used to watch it together
in college and i love how watching it
with them now makes me feel.
i love how it makes them feel.
we reminisce.

"

—CASSANDRA

she trains our store team members,
and uses wineglasses as water glasses
simply because they feel celebratory.

# your friend is having a baby!!!

DESPITE ITS NAME, a baby shower isn't as much a party for the future baby as it is a big show of support for the parent-to-be from all the friends and family who've got their back as they embark on the great adventure of parenthood. make a show of your support now, so they know who to call when things get swirly later.

looking ahead, consider that it's going to be all about the baby for a while, so the shower is a moment to shower your friend with indulgences.

# for the low-key parent-to-be

not everyone wants to be the center of attention. if a woman is carrying the child and is 39 weeks pregnant, she might be too tired, too puffy. or maybe this is their third kid and they would rather tone it down a notch.

- trade cupcake towers and games for a pedicure and matinée rom-com with two close friends, or a chic lunch at a restaurant of their choice plus a museum exhibition midweek.

- consider packing their freezer with homemade soup for nourishment once the baby arrives. (they won't know how good this gift is until later, so expect delayed, exuberant praise.)

keep the tone light and positive and try not to harp on the lack of sleep in their future. rest assured, they have heard that many times already.

# for the one who likes a party

some people need a good old-fashioned party to take the leap from one life stage to the next. this might very well be the last adult event they have for a good period of time, so make it count. even rope their partner into the planning.

A BIG BRUNCH:

- outsource the bagels and schmear and order or make their most favorite side dishes.

- set out pitchers of nonalcoholic beverages with booze on the side for guests to spike their own.

- task friends with bringing flowers in a specific color palette, and make it an activity to arrange them as they arrive (the parent-to-be can take these home after the event).

- invite a select group of friends.

- the future parent won't likely have a chance to get all glammed up in the immediate future, so book them a blowout or a haircut.

- break out the champagne alongside low/no alcohol sparkling options on recommendation from your local wine shop.

- task their friends with masterminding one course of the meal, or lean into the amuse-bouche and the sophisticated dessert, then order the best pizza you can find as your main (side note: you'll be hard-pressed to find a pregnant woman whose eyes won't light up at the sight of pizza), and serve it on your best china.

## more side notes

a truly successful event balances out all the feelings in the room. if someone seems unresponsive in the planning, give them space. baby showers can be triggering for a variety of reasons:

- the topic of babies can be painful if someone's struggling with their own fertility or family planning, even if they're a generous friend.

- finances can be a burden to anyone on a budget, so consider skipping the public opening of presents.

- provide comfortable, meaningful ways for friends to contribute to the event that require thought and care but are easy on the wallet. adding a charitable donation for gifting is always a nice touch: guests with limited means can give something as small as a pack of bottles to a family in need and know that they made a meaningful contribution.

# presents

chances are, your friend is going to receive more gifts for the baby than they need, particularly tiny clothes. consider this an opportunity to get something special to spruce up the "go bag."

- GRIPPY SOCKS AND SLIPPERS: great for pitter-pattering down the hospital halls and even during labor.

- LOUNGEWEAR: stylish pajamas that open in the front for breastfeeding. look for drawstring pants for the transition from pre- to postpartum or a modest, loose-fitting nightgown (nothing sheer or revealing).

- EYE MASK: hospital staff come in and out of the room all night long, so a well-made eye mask is essential.

- TUNES: enlist friends to curate a series of playlists for postpartum. make sure they have a portable speaker to take with them as well.

- SNACKS! essential during and after labor (giving birth is similar to running a marathon). make or buy healthy granola, a seasoned nut mix, or a bag of fancy dried fruit. she will need all the healthy fats she can get. recipes for lactation bars and cookies can be found online—make them ahead so she can pop in her freezer and bring them along.

- FANCY TEA AND A TRAVEL MUG: warm beverages are comforting in the days after giving birth, but the hospital won't have the most appealing options. gift her some beautiful bagged tea (loose leaf is too messy), and a new travel mug. lactation teas are a plus if your friend plans to breastfeed.

- SWEET SCENTS: an aromatherapy diffuser will give the sterile hospital room some vibe. pack her bag with calming lavender or clary sage, thought to speed up labor and reduce pain (also, it just smells like heaven).

# your friend is ~~having~~ *had* the ~~a~~ baby !!! ...

BRACE YOURSELVES. hormones might be crashing, time is definitely a black hole, and anxiety is likely through the roof, so even your smallest overtures at this moment in time will make a lasting impact. create space for the new parents to reconnect with and celebrate the big picture—they made a tiny human, and they are keeping them alive!—while you celebrate the fact that it does indeed take a village, and their village has arrived.

# get on the meal train!

organize friends to feed the new parents as all their energy goes toward feeding the baby postpartum. compile email addresses and sign up for one of the online platforms that make the process easy. once the baby has arrived, send out a link to the meal train page, and let people either select a date to drop off homemade food or purchase credit with any of the delivery apps for the family to use at their discretion.

# lend a hand with the small stuff

you might have been invited over to meet the new baby, but the infant is a red herring: arrive with a mission to complete at least one household task before getting distracted. insist that the new parents assign you a decidedly unglamourous chore: do the dishes, walk the dog, break down delivery boxes, do a load of laundry. it doesn't sound like much, but it will help alleviate their sense that their world is in a state of chaos.

# give them a break

if the baby is sleeping, offer to watch the baby while the parents take showers or a walk around the block. (bear in mind many parents are not comfortable with friends or family holding the newborn in the first weeks.) your mantra: you are there to help, not to be entertained.

# offer a little moment of pampering

if you are on a budget, bring over a manicure kit and paint mom's nails. if you have some cash to spend, treat her with a gift certificate for a postpartum massage. there are masseuses that specialize in postpartum body work, and there are also doulas that pay house calls.

AND if it's your boss, a coworker, or someone in your friend circle, gift them a meal delivery service or send a big basket of easy-to-prepare nourishing foods (seasonal fruit, heirloom tomatoes, citruses, snap peas, prewashed salad greens, pickles, artisanal bread . . . things that can be easily eaten with nothing more than salt and oil).

# how paula sutton
## sets a

# celebratory
# scene

A TABLE ABUNDANT WITH LIVELY CONVERSATION AND INDULGENT FOOD IS HILL HOUSE VINTAGE FOUNDER PAULA SUTTON'S JAM.

IT'S COTTAGECORE WITH A DASH OF COSMOPOLITAN GLAMOUR, LONDON (FORMER HOME) MEETS THE ENGLISH COUNTRYSIDE (CURRENT HOME), WHERE SHE HAS SPACE FOR TRUNKS FILLED WITH TABLE LINENS, CANDLES, AND ACCESSORIES OF EVERY COLOR, FOR EVERY OCCASION.

## for friends:

"i like to fully immerse myself in celebrating my friends, rather than have to rush back into the kitchen, so it's cocktails and canapés somewhere exciting and away from home. i go the extra mile in the glamour stakes and choose somewhere new and different each time."

## for her wedding anniversary:

"our supposedly 'romantic a deux' anniversary dinners are actually gloriously lively family affairs where our three children plus my son's girlfriend all come out with us for dinner, or we host a formal meal with them at home."

## for a cocktail party:

"i love the novelty of bite-sized traditional english nursery foods. i'd serve mini macaroni and cheese truffle bites, mini yorkshire puddings with a slither of beef topped with horseradish sauce, and mini 'toad in the holes,' which are like yorkshire puddings with tiny sausages! they look incredibly cute but are also delicious."

## for a formal dinner:

"i'd serve a monkfish main course in a buttery sauce, with creamed spinach, french beans, and potato dauphinoise, and a generous portion of crème brûlée for pudding."

## to really wow:

"i put out a mountain of chocolate profiteroles filled with fresh cream or trays of mini strawberry pavlovas. they look sensational on the table and can be made in large quantities relatively easily."

# *be a good guest and...*

. . . **DRESS UP.**
it's a compliment to the host and puts you in a celebratory mood.

. . . **RSVP TOUT DE SUITE.**
always respond to an invitation within three days of receiving.
if you are suddenly unable to attend, give your host ample notice.

. . . **ALWAYS BRING AT LEAST TWO BOTTLES.**
if the host says "just bring wine."

. . . **TIME YOUR ENTRANCE.**
don't show up early.

. . . **DON'T BRING AN UNEXPECTED ENTOURAGE.**
if you're hoping to bring a plus-one (or two, or three), check with the
organizer in advance.

. . . **MAKE A DRIVE-BY, IF NECESSARY.**
plan to spend at least 45 minutes at a cocktail party, even if you're
only having one drink.

. . . **PUT DOWN YOUR PHONE.**

*when is fashionably late just late?*

DINNER: no more than
20 minutes, please.

COCKTAILS: arrive whenever.

EVENT: don't be late
for the wedding.

# they've come out

—ELLIOT PAGE

THEY ARE ONE STEP CLOSER to fully embracing who they are, and this person's brave steps should be celebrated. their privacy, and their right to share this news when, where, and how they decide to, should also be respected in the process. here are ways you can help applaud them.

- tell them you see them, and validate their identity.
- ask how you can support them.
- ask how they identify, if/how they'd like to be identified, and what their personal pronouns are. share your own pronouns in your email signature and video profile to create visibility in your everyday language usage.
- research books, websites, social accounts of LGBTQIA activists and advocates to learn about the issues being discussed.
- send them a meaningful gift—a book, piece of artwork, piece of jewelry, special dish or drink—to lift them up.
- ask if they want any kind of public celebration, and if you're willing, offer to host it for them. don't assume they want rainbows. don't assume they don't. ask. encourage them to share if and when they want to.
- open some bubbles of whatever sort they choose, and toast the person.

# you've lost someone

A FUNERAL MAY NOT FEEL LIKE a particularly celebratory occasion—it would seem to be, in fact, exactly the opposite. but gathering family and friends together to honor someone you held close can be a significant celebration of that person's life.

the pain of losing someone you love can be overwhelming. a planned moment to cry and laugh, talk and have a drink, maybe even sing and play music, all united by your positive memories of the person, can be a healing marker of the closure of a meaningful relationship. you're coming together to grieve and to love. joy makes us resilient.

# gathering in their honor

when a very dear friend passed away at the age of 50, her husband threw her a wake at the jane hotel in manhattan with two hundred people, and for three hours, everyone sat around talking about her and how amazing she was and how she threw chic cocktail parties with good food. she was a glamorous bon vivant, a film producer, and the wake was exactly what she would have wanted to have. it was moving, a portrait of who she was, and celebratory—everyone was dressed glamorously, just like she would have done.

if it was a tradition to sing and play music whenever you got together, open some wine and beer after the reception and do just that.

with each year that passses, honor them by eating their favorite dessert on their birthday.

# expressing sympathy

while it can be hard to know what to say or write when someone loses a loved one, there are some universal truths:

- acknowledge their loss, and if you knew the person too, or heard nice things about them, express a thoughtful memory.
- avoid the phrase "i know how you feel." every relationship is unique, and so is every loss, and so is every person's experience of a loss.
- take the time to listen. if they want to talk, sometimes just being present and listening is the best thing you can do to help.

AND if it's a close friend, family member, or person in your community who has suffered a loss, arrange a simple bouquet of yellow roses for them on that day each year.

AND if it's your pet, host a wake to honor this devoted member of the family. invite their walker and groomer, plus family, friends, and neighbors who enjoyed their companionship. put together a slideshow of their most adorable moments. raise a glass, share stories.

# dad's retiring

IT'S FINALLY HAPPENING! soon, every day will be saturday.

- host a comedic roast if they have a sense of humor; a balance of wisecracks and heartfelt compliments from coworkers and loved ones. cap the night with dad's speech so he gets the last laugh.

- theme your party around either the year dad was hired for this job, or the year he got his first job (waaaaay back when). base the dress code, the decorations, and the food all on that era, and get photos of dad from that year to flaunt.

- build a party around his favorite hobby: rent out a bowling alley, a day of group fly fishing, host a big backyard bbq and let him be in charge of the grilling station (group present: fancy new grill).

- pick a silly theme: "permanent vacation." make it a pool party or host it at a local beach, set out inflatable palm trees, serve beer and tropical cocktails, and invite guests to dress with cabana style.

# gifts that wow

...................................................................

TAKE ANY GIFT UP A NOTCH combining one part forever keepsake plus one part fleeting folly. (most likely, you've got one of these two in mind already, so it's just about adding the other.)

on a friend's 30th birthday, a newish acquaintance and eccentric collector arrived at her door with an unexpected personal gift: a petite bouquet of pink carnations—her birth month flower. then he tucked the frilly budget blossoms into a vintage lady head vase, a vessel that was popular from the 1940s to '70s and made by only a handful of manufacturers in the u.s. and japan.

the vase has long outlasted the carnations, corralling makeup brushes atop a bathroom sink and assorted nubby pencils on a home desk. she even bought a few more lady head vase friends over the years, and they've been known to make an appearance at intimate luncheons at each place setting and boozy bridal showers marching down the center of a buffet table.

here are combos that are fifty percent now and fifty percent forever . . .

- a hand-woven basket of persimmons
- six chocolate bars bundled into a silk scarf
- a caddy of classic sticky notes and a fountain pen
- a medley of hard, soft, and stinky cheeses, curated from a single country, on a slate slab
- a high-pigment lipstick (classic red!) with a vintage brass compact
- homemade marmalade and a sterling-silver toast caddy
- a dozen beeswax tapers—some smooth, some ribbed, some twisty—and a pair of arty candlesticks
- a bottle of small-batch bourbon and a flask monogrammed with the celebrated's instagram handle
- a trip somewhere, along with new carry-on luggage

# surprise parties

EVEN THE MOST JOVIAL PERSON can find them overwhelming. if you're giving one, remember you're doing it for this other person, not you, and match the level of surprise, as well as all the elements of the party, to the recipient.

if you're the unexpected guest of honor, show your feels. (it is your party, you can get mad if you want to.) long after your nightmare is over, you'll fondly remember that a bunch of people loved you so much they did some stealth planning, gathered together, hid in the dark, and then shouted their deep affection for you at the top of their lungs to totally freak you out.

# oops.
## that didn't work.

CELEBRATING THINGS THAT HAVEN'T GONE RIGHT IS, flipped around, the belief that we can be better and that things will go right in the future. it's a celebration of the beautiful scope of normalcy.

because learning from our mistakes can change our life and also the lives of those around us for the better (yay to that), it's big stuff. the next time you find yourself thinking "uh-oh":

- look for something to enjoy in the challenge and decide to fail forward. that way, you're always leaning in the right direction.

- remember the power of appropriate dosing with humor. when things are at their worst, try cracking a joke. it can give you a much-needed lift thanks to a replenishing and energizing brain chemical called dopamine, which could, in turn, help reframe your mindset.

things usually make sense
in time, and even
bad decisions have their own
kind of correctness.

—MIRANDA JULY,
*no one belongs here more than you*

what
are you
going
to wear

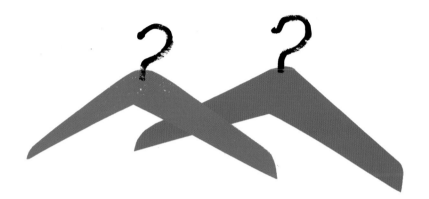

LOTS OF DRESS CODE REQUESTS get bandied about on invitations, all of which can get confusing, and none of which are set in stone.

there are the rules, and then there is this: *always overdress.*

it's fun being the most overdressed person in the room, leaving everyone to wonder what fabulous thing you just came from.

so read on, get better acquainted with these the ins and outs, and if you're in the mood for fun, take your outfit up a notch (or many notches) from there.

## THE REAL DEAL WITH BLACK TIE:

this is the go-to dress code for most fancy social events. a formal floor-length gown is preferred, but not the rule, so grab your fanciest finery whatever it is, or borrow or rent something fabulous.

if you're borrowing something, remember:

- return it cleaned, wrinkle-free, folded or on a hanger.
- return it promptly.

- replace it with an identical item if something happens that makes it unwearable (red-wine stain, a tear from doing the dougie on the dance floor, sweat on silk). if that's not possible, offer to reimburse the owner with cash.

## BLACK TIE OPTIONAL:

just as fancy, yet even more vague than black tie. expect to be mingling with cocktail dresses worn with glamorous jewelry, tux-style pantsuits, and little black dresses right alongside glittery frippery and feathery fancy.

## COCKTAIL ATTIRE:

dressy but fun: in a crowd of little black dresses, make a statement in shocking pink, lipstick red, and other bold colors.

- cocktail dress (obviously) + statement clutch + red nails
- little red dress + chic heels
- clinking bangles go well with clinking ice

## SEMIFORMAL:

lots of room for interpretation here, so focus on fabrics: silky, satiny, tulle-y separates.

- floor-length skirt + crisp white tee
- elegant jumpsuit + sparkly heels

## FESTIVE:

it's time to reach for that really special piece in your closet that you never have a "reason" to wear.

make this the dress code anytime you're going for a drink with your girlfriends, your daughter, or anyone else who will "get it" and dress to the nines, too, no matter how everyday the occasion.

## CREATIVE:

permission to add fun and novel accessories to anything.

- conversation-starting bag (this works for all dress codes, really)
- big, bold necklace
- sheer top + jeans + bow kitten heels +  sparkle

## TROPICAL/DESTINATION:

breezy with a little silver-screen glamour.

- ruffled dress + slicked-back hair
- floral sundress + cat-eyed sunglasses
- white cigarette pants + raffia clutch
- cocktail dress + flip-flops
- printed maxi dress + sandals + the biggest gift
- wrap dress

*note*:
a little black dress with feathers somehow always works from this dress code on up.

## BUSINESS FORMAL:

pick whatever you'd wear for a big presentation or board meeting at work.

## BUSINESS CASUAL:

choose something professional you can wear to work during the day that you call also wear at night. the bow blouse you've had tied since 9 a.m.? now untie it.

- a tailored jumpsuit and heels
- blazer + open collar shirt or sweater + pencil skirt + heels
- shift dress + sleek boots
- tweed dress

look polished. this can be as simple as a wrap dress or a white shirt and crisp trousers, if it's something you love that loves you back. no sneakers.

## CASUAL:

what you'd wear to get lunch with mom, not what you'd wear to brunch with your roommate.

- a long skirt + plain tee
- eyelet dress + denim jacket
- embroidered blouse + sailor jeans + sandals
- striped top + nice jeans + ballet flats

## a few more things to consider:

- time of day
- location (formal in a garden might call for fancy flats.)
- your role in the festivities

do a little planning and leave some room for last-minute spontaneity. make something up out of what you have that day. no matter what the occasion, wear your favorite colors and make sure whatever you put on is comfortable.

## THE MORNING AFTER:

the dress code for going out to get a bacon, egg, and cheese the morning after any occasion: pajamas + fluffy coat + eyeliner.

IT'S FUN BREAKING THE RULES. *when manhattanite nan kempner was turned away from swishy uptown restaurant la côte basque because she was wearing a pantsuit (it was the 1970s), she wiggled out of her trousers and went in wearing just her jacket-now-minidress. nan kempner: "i put a lot of napkins in my lap and didn't dare bend over."*

# 12
## things
## in your
## wardrobe

THAT ALWAYS FEEL FESTIVE

○ PINK TOENAIL POLISH

○ BANGLES

○ BOLD COLOR

○ SPARKLE

○ HIGH HEELS

○ STATEMENT SHOES

○ BIG, BIG, BIG EARRINGS

○ RED LIPSTICK

○ FIT-AND-FLARE SKIRT

○ PANTSUIT

○ FRESH FLOWERS IN YOUR HAIR

○ COCKTAIL RING*

*during illegal cocktail parties of the 1920s, women wore oversized rings on the same hand that held their cocktails. these big jewels became known as cocktail rings.

BLAIR EADIE IS THE FOUNDER OF FASHION AND PERSONAL STYLE SITE ATLANTIC-PACIFIC.COM, AND HER "MORE IS MORE" WAY OF DRESSING APPLIES TO THE BIGGEST GESTURES AND THE SMALLEST TOUCHES. SHE'LL MAXIMIZE A NEW YEAR'S CELEBRATION BY DOING IT THE DAY BEFORE (NO CROWDS!), AND REGULARLY CELEBRATES NON-CALENDARED OCCASIONS, LIKE THE FIRST SNOWFALL OF THE YEAR.

i'll joke that i always want
to look like the party,
and I do believe an occasion
is the perfect excuse
to wear all of your fanciest
accessories. in general,
i'm a big supporter of maximalism
and love all things over the top.
color, embellishment, tulle . . .
all of these things make me
feel festive. the higher the heels,
the bigger the dress, the better.

—BLAIR EADIE

# their wedding!

AS A GUEST, weddings are, quite frankly,* the best. whether you are a hopeless romantic and the kind of person who cries at movies, or a curmudgeon whom a cat meme can't melt, there is no reason to not be in a good mood at one. people you love are declaring their love. to each other! food and drinks are being served to you, you're bumping into people you haven't seen in years, and it's a fresh spot to meet a new someone if you're single. everyone is on their best behavior, there is optimism everywhere, and emotions are flowing like a champagne tower: this is your excuse to weep in public, hug everyone you see, and believe in love.

other people's weddings can be as much a celebration for you as for the couple at the center of it all. your hosts have put so much effort into making sure it's a fantastic experience. just remember that it's not *about* you, dear guest. there's no wedding without "we."

*other people's weddings are the best when they're done well and everything is given exactly the right amount of time. this generally involves the following: a cocktail hour. a ceremony that isn't too long or too fast. a meal served promptly and quickly and the toasts given during it.

all this leaves time to turn the dance floor into the party of your lives, and enough time for the couple to surprise guests much later in the evening while madonna is playing full blast, with pizza delivery and an ice cream truck to fuel everyone on, including themselves, for a few more hours.

in short, less time spent doing things less fun, more time doing things more fun.

## this is an excellent ~~excuse~~ occasion to:

- buy or pamper yourself with something new: a dress, a blowout, lash extensions.

- go somewhere you've never been if it's a destination wedding and perhaps make a vacation out of it. hope for paris or new orleans, but a trip to visit their hometown will be fun, too.

- on the day, make it a day: have your own pre-cocktail hour with other guest(s) or your plus-one before going to the ceremony.

## be a fantastic guest

- if you know either half of the couple directly, make yourself available. if one of them needs an orange juice, go get one. it's a way you can make sure they feel appreciated for everything they did to plan the event, because it was a lot.

- if you're giving a toast (first: find out if the couple even want them), be warm and generous. avoid the embarrassing college stories, even if they feel relevant. you want to shine the best light on these two people you love.

- get people chatting, introduce people to each other, and make sure the people around you are having a good time. introductions help people feel included and can jumpstart a conversation. start with the basics. ("sara, meet julie.") follow that up with an interesting fact about each person that might be of interest to the other person. if someone new is being introduced to your group, be sure to include them immediately in the conversation by asking them a question.

- keep any conversation flowing by asking two simple questions: "what?" and "why?" (what happened? why'd they do that?) avoid suggesting answers in your questions—more likely that's how you'd respond to the question. and avoid asking "yes" or "no" questions unless you're asking whether they'd like another bacon-wrapped date with goat cheese.

## here comes the gift

- you don't have to spend a fortune, but do get your gift within twelve days, or else it'll just sit on your to-do list till the last minute.
- always buy off the registry, unless you know them very well and know exactly what they would like. otherwise, they've told you what they want. show your creativity with the wrapping or the card instead.
- if you like taking photos, bring an instant camera and ten rolls of film to the wedding, snap candids the couple wouldn't get to see otherwise, then deliver the photos to their hotel as a fun surprise souvenir.
- if you're more of a words person, organize for everyone to write the new couple a letter about your favorite memories from the wedding. (this is especially good for destination and multiday events.) send them a couple of weeks after they've returned from the honeymoon—right about the time the high from the wedding will be settling down. it'll be a fun way for the newlyweds to relive the occasion and see their wedding from their guests' perspective, most of whom will have a wild story to tell.

> "
>
> their wedding is one of my
> happiest memories.
> a big beautiful wedding, and
> the band was incredible.
> i remember standing next to
> my cousin, screaming to
> a beyoncé song, sweaty on
> the dance floor and
> having the time of our lives.
>
> "

—JESSICA

she is a member of our social impact team

if it's 4 a.m. at the wedding, as a guest you might as well go the full distance. staying up until dawn has a certain cachet, and there's a kind of magic in hearing the first birds sing and seeing the sky turn on its light switch. walking barefoot across a summer lawn, an empty street, or a deserted beach, full hearted, giggling and yawning. things that happen at weddings don't end at weddings. for all of you, each guest included, this is just the beginning.

# the *wonderful* thing about after-parties

THE VERY TAIL END OF A CELEBRATION is a time when anything goes. if it's been a big party, everyone is usually ravenous, which can result in some bizarre impromptu picnics—hummus and greek yogurts from the back of the fridge, tinned tuna, a delivered pizza—all consumed with mardi gras enthusiasm. the ones left at the end of the night are usually your favorite people, with maybe a new face or two joining in, so shoes are off and the stereo is dialed up. inhibitions left hours ago (they're always the first to pack up and generally prefer making french exits), so you might sneak a little kiss, someone you just met may now be your new best friend, and everything seems bright with possibilities. *a trip to florence would be so fun! cat socks would make millions! weekly lunch is on!* **by the end of the night, everyone is a guest of honor.**

we love celebrations in all their forms and sizes because each one of them is full of promise; the promise that when you go out and do things, good things will (hopefully immediately, but also eventually, finally) happen. promises give us hope, and hope has a way of reenergizing us, propelling us all on to the next occasion in our lives that makes us think, "i should celebrate that."

# index

# credits

## extra small

**17 IRBY QUOTE:**
excerpt(s) from *meaty: essays by samantha irby*, copyright © 2013, 2018 by samantha irby. used by permission of vintage books, an imprint of the knopf doubleday publishing group, a division of penguin random house LLC. all rights reserved.

## small

**22 CARDI B QUOTE:**
bowen, sesali.
"quote or lyric: cardi b edition."
refinery29.com.
23 february 2018.

**50–51 KANDISKY QUOTE:**
winston, danielle.
"mindful decoration: the psychological meaning behind colors."
brentwoodhome.com.
17 april 2019.

**059 FITZGERALD QUOTE:**
fitzgerald, f. scott.
*the great gatsby.* scribner, 1925.

**76 LEBOWITZ QUOTE:**
*pretend it's a city.* dir. martin scorsese. perf. fran lebowitz and martin scorsese. netflix, 2021.

**78 SEX AND THE CITY QUOTE:**
*sex and the city.*
dir. michael patrick king. perf. sarah jessica parker and kristin davis. warner brothers. 1998.

## medium

**88 LOCKHART QUOTE:**
excerpt(s) from *we were liars* by e. lockhart, text copyright © 2014 by e. lockhart. used by permission of delacorte press, an imprint of random house children's books, a division of penguin random house LLC. all rights reserved.

**95 PERIGNON QUOTE:**
long, tony.
"aug. 4, 1693: dom pérignon 'drinks the stars.'" wired.com.
4 august 2009.

**100 FITZGERALD QUOTE:**
english, michaela.
"zelda fitzgerald's best quotes."
townandcountrymag.com.
24 july 2015.

**129 LERMAN REFERENCE:**
regensdorf, laura.
"gray foy, a master precisionist who presided over legendary salons, gets a turn in the spotlight." vogue.com.
16 november 2018.

**139 VREELAND QUOTE:**
fisher, lauren alexis.
"diana vreeland's most memorable quotes." harbersbazaar.com.
29 july 2014.

**145 WHARTON QUOTE:**
lee, hermoine. *edith wharton.*
vintage books, 2008.

## large

**151 ALBOM QUOTE:**
albom, mitch. *the first five people you meet in heaven.* hyperion, 2003.

**152 ELSON & WHITE QUOTE:**
reuters. "rocker jack white and wife throw a divorce party."
today.com. 10 june 2011.

**159 NERVAL QUOTE:**
liles, maryn.
"these 101 enchanting quotes about nature will have you dreaming of the great outdoors."
parade.com. 7 may 2020.

**165 DE SHIELDS QUOTE:**
*vibe.* "andre de shields, legendary broadway actor, takes home his first tony award." vibe.com.
10 june 2019.

**173 ORR QUOTE:**
moore, suzanne.
"deborah orr was unflinchingly true to herself. who among us can say that?" theguardian.com.
22 october 2019.

**158 AUSTEN QUOTE:**
austen, jane. *emma.*
woodsworth edition, 1997.

**201 HEPBURN QUOTE:**
fernandez, francisco.
utrgv.edu.
21 april 2015.

## extra large

**224 PAGE QUOTE:**
page, elliot. twitter,
1 december 2020.

**229 KEMPNER QUOTE:**
horwell, veronica.
"nan kempner: couture collector at the heart of new york's fashion elite." theguardian.com.
25 july 2005.

**223 MIRANDA JULY QUOTE:**
july, miranda. *no one belongs here more than you.* scribner, reprint edition, 2008.

EDITOR
**rebecca kaplan**

DESIGN MANAGER
**jenice kim**

MANAGING EDITOR
**lisa silverman**

PRODUCTION MANAGER
**denise lacongo**

Library of Congress Control Number: 2018958799

ISBN: 978-1-4197-3863-0
eISBN: 978-1-68335-660-8

Text copyright © 2022 kate spade new york

Cover © 2022 Abrams

Printed and bound in the United States
10 9 8 7 6 5 4 3 2 1

Abrams books are available at special discounts when purchased in quantity for premiums and promotions as well as fundraising or educational use. Special editions can also be created to specification. For details, contact specialsales@abramsbooks.com or the address below.

Abrams® is a registered trademark of Harry N. Abrams, Inc.

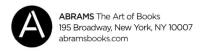

**ABRAMS** The Art of Books
195 Broadway, New York, NY 10007
abramsbooks.com

EDITORIAL DIRECTOR **jen ford**

CREATIVE DIRECTOR **kellie yuan**

COVER CONCEPT **claudia wu**

CONTRIBUTING WRITERS **roxanne fequiere, ali gay, taylor halle, amy perry, julia sherman, cassandra campbell stanley, elizabeth wallace**

ARTWORK **lucy jones**

MANAGING EDITOR **katherine dileo**

# "i'd like to make a toast!"

it's time to raise a glass to all of our spirited, inventive, clever colleagues and friends who made this book a joy to treasure:

to **liz fraser** and **jenny campbell** for your guidance and your love of what makes our brand so special.

to **cynthia andrew, cassandra campbell stanley, jackee de lagarde, blair eadie, hannah goldfield, victoria haworth, alex landires, jennifer masella, kristen naiman, michele parsons, loris jaccard sandoz, ebonie simpson, paula sutton, payton cosell turner, jessica viets, jenny walton, charlotte warshaw, ayako yanagisawa, and wen-jay ying** for being so generous with your time and your stories. cheers to **anastasia strizhenova** for that, too, plus making us your glorious cakes.

to **kelly sandoval**, for navigating all kinds of logistics with grace, and to **katherine dileo** for resetting the clock and always picking up the phone when we called. to **elizabeth wallace**, for your meta cleverness and big picture thinking.

to **carmen arocho-blanco, georgia harmos, anna hobson, tom mora,** and **karen reinitz** for your love of reading. to **samantha montes** for getting to the source. to **karla aspiras**, for your legal how-tos, and to **rebecca kaplan**, for continually putting your trust in us to do what we do best.

to everyone here and on our **kate spade new york team** around the world, thank you.

*it simply wouldn't be a party without you.*

# thank you

*this was so much fun!*

*let's do it again*